Basic Photography

MARVIN WEISBORD

*Formerly Photography Instructor,
School of Journalism,
Pennsylvania State University*

Third Edition

AMPHOTO

American Photographic Book Publishing Company, Inc.

GARDEN CITY, NEW YORK

Library of Congress Catalog Card No. 72–93374

ISBN 0–8174–0423–6

Introduction:
Some Words About Picture-Taking

It's hard to believe there's anybody over the age of 10 in America who's never taken a picture. If there is, this book is for him. But it's also for anybody who's ever taken a picture and wished it were a better one.

"Basic Photography" doesn't tell you which camera to buy, whether to own a bagful of gadgets, or how to develop film in a jiffy. It does tell you how to take *pictures*—good pictures. It tells you where, when, and how to see them, create them, and put them onto film. It tells you how to make people look like people and buildings look like buildings and scenery look like scenery instead of postage stamps cancelled by hand.

The real test of a snapshooter is not whether most of his pictures "come out," but whether they're any good. In photography, no less than fishing, nobody wants to hear the story about the great one that got away. How good is the one you got?

Most of the pictures in this book are snapshots. Almost any of them could have been taken with the simplest camera, without accessories, gadgets, or fancy techniques. This book tells you how to take pictures as good as these (or better) in a short time, even if you've never handled a camera.

You can apply most of the tips that follow to the simplest cameras, but I realize that more and more people are buying adjustable cameras as prices fall and color-slide fever rises. Most of the picture-taking "rules" apply to both black-and-white and color pictures. So this book will help you improve your color slides and prints.

But—let's face it—to use an adjustable camera the right way, you have to understand the adjustments. So I've included information on shutter, lens, and film speeds for people who need it. I've tried to make this medicine fairly easy to take by using words you're likely to recognize. But please take it if you also want to take good pictures.

I took most of the pictures in this book. Some were made by relatives and friends whose names appear under their

work. I'm especially tickled to acknowledge the series on pp. 52-53, taken for this revised edition by Joe Weisbord, a teen-age photographer, who was the baby in this same series of pictures in 1959. This time the baby is Joe's brother Dan. Their sister is Nina Weisbord, who also appears with brother Bobby Weisbord on page 39 –thus making this a Weisbord family album.

I also want to thank photographer Joe Nettis and Prof. Charles H. Brown for help with the original edition and David Willis for his contributions to this one.

MARVIN WEISBORD

Contents

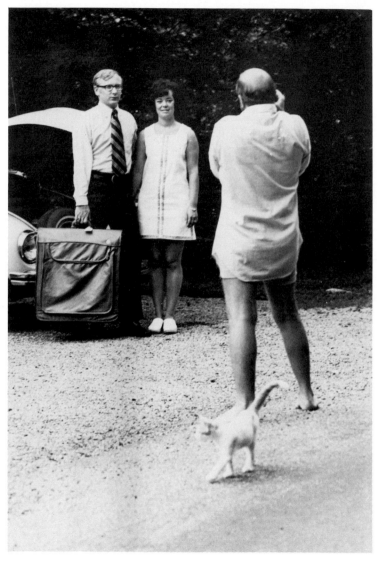

David Willis photo.

1. My Friend George

To explain some of my ideas about snapshooting, I've invented a straw man named George. You set up a straw man so you can knock him down, and George gets knocked around plenty in "Basic Photography." But he deserves it. George takes pictures the way some people cross streets—without looking. His are some of the world's worst snapshots. Because George is a fictitious character, I can use him as I please; and I've decided that he does more things wrong with a camera than anybody you've ever met. On the other hand, everybody probably does *some* things like George. Let me tell you more about him, and see if you don't agree.

George owns one of the 70 million cameras in use today. He likes to take pictures of his family and his friends. But he's not what you'd call a serious amateur. What I mean is, he doesn't develop films in the bathroom and print them in the basement. He'd rather let the drugstore worry about that stuff. He doesn't know a thing about filters, tripods, lightmeters, lens shades, reflectors, floodlights, or other gadgets. "I just like to snap the wife and kids now and then," George says. "You know, family album stuff."

Of course he wishes he had "more time" to really learn how to take pictures, but whenever he sits down with his camera and a photography book there's a show on TV he just can't afford to miss. In a year, though, George takes a lot of pictures—the kid's birthday party, a family trip to the zoo, vacation shots of six historical markers and three famous buildings, all with Mrs. George standing in front of them.

What really bothers George is that nobody appreciates his pictures. He can't understand why, because they nearly all come out. But he still gets comments like this one from his wife: "You've never taken a picture that looks like me yet." Or from his son, George Junior: "Gee, Dad, you cut off the top of my head again."

Somewhere along the line a store clerk told George that, if he would throw away his old box camera and buy a *Super*

Beautycord, his troubles would be over. So he did. But his pictures didn't get any better, and he hated messing with all those dials anyway. So he went back to the box.

What's wrong with George's pictures? Well, *his* idea of a good shot is to line up his wife and kids in front of the house, back off about 20 ft so as not to miss anything, and fire away. He faithfully follows this procedure for every picture, no matter who or what's in it. The people in his pictures never do much of anything except get older down through the years. The backgrounds change, but not the angles. Sometimes there's too much sky and sometimes too much sidewalk. Often there's so much of both you can't see the people at all.

Now and then George shakes his head as he flips the pages of a picture magazine. "Boy," he says, "those guys are really good."

"Well, dear, why can't *you* get shots like theirs?" his wife asks sweetly.

George knows she's kidding. "Heck," he says, "you know what they do, don't you? They take about a thousand pictures just to get 10 good ones. I guess if I took that many a few of them would be pretty good."

But in the last 20 years George *has* taken a thousand pictures. They're all over the place—in the bottom bureau drawer, on the top shelf of the hall closet, pasted in the family album, in the kids' scrapbooks. I wish you could see them sometime. If you found 10 good ones George would be more surprised than anybody. Even he knows that when you come right down to it they all look alike.

Know Any Georges?

George, unfortunately, isn't purely an imaginary character. You see him wherever shutterbugs gather—at vacation resorts, on mountain tops, at airports and parades. He's the guy who's always lining people up to have their pictures taken, the one who makes you "hold it" or "say 'cheese'" or "watch the birdie." He's the guy who's always looking over his left shoulder to make sure the sun's there.

And he doesn't like photography books or "technical junk." He thinks that once he's learned to put the film in the camera he's got the world by the tail. The funny thing is, he doesn't even do that right most of the time. Usually his roll comes loose and some light leaks in around the edges.

Oh, sure, George glanced over the book that came with his camera when he bought it years ago. Only he never got any of the correct information out of the book, and over the years he's picked up a set of myths about picture-taking that make him feel comfortable, because all his friends believe them too. Here are a few of them:

The better your camera, the better your pictures.

All pictures should be posed.

If you make people *pretend* to do something, your picture will be natural-looking.

You can't take pictures in the house without flash bulbs.

Outside you have to have the sun over your shoulder.

When you're taking a picture *you* have to be in the sun as well as your subject.

If your pictures all "come out," you're a great photographer.

Now the fact is that *none* of the above statements is true. But George isn't alone in believing them. I'll bet you can think of at least a couple of other people who do. In the following chapters you'll see why these beliefs are false and how they hurt your snapshots.

What I've tried to do in this book is show George's customary pictures alongside the ones he *might* have taken had he waited an extra second, changed his angle slightly, spoken a word to his subjects, or paid some attention to his viewfinder.

I believe that anybody, including George, who wants to improve his pictures can do so without learning a lot of "technical junk." But he will have to think a little bit. And he will have to practice what he's learned. It's really no harder to take good snapshots than bad ones.

I once heard a wit say that "the worst examples of snap judgment are usually found in a family photo album." I suppose he was talking about George's, but did he also mean yours?

2. "Hey, Buddy,
What Kind of Camera You Using?"

Like most people, George is impressed by fancy cameras. He's seen some of the elegant jobs tourists sometimes carry; every once in a while he wishes he knew how to twirl the right dials and pull the right levers to make what he's sure must be really sensational shots. George has watched the scene that follows at least a dozen times, always with a tinge of envy. Maybe you have too.

Usually it happens while you're on vacation. Let's say you've just climbed to the top of the Washington Monument or taken an elevator to the observation tower on the Empire State Building. Or maybe you're standing on the rim of the Grand Canyon just before sunset. Anyway, the people on all sides of you are furiously snapping pictures with every variety of camera ever made. At least one guy in the crowd is waving around a pretty fancy 35mm job. It has a telephoto lens about 6″ or 8″ long, an auxiliary viewfinder, and a red filter as well as a synchronized lightmeter. Across one shoulder the man has a gadget bag the size of a Boy Scout knapsack. He's setting up the camera on a slick-looking aluminum tripod, and when he's satisfied himself that the sun is just right, he begins snapping pictures more furiously than anybody else.

After a while one of the other picture-takers saunters over, making a big production out of adjusting the lens on his own camera. "Hey, buddy," he says to the first man, "what kind of camera you using?" His voice holds just the right mixture of awe and reverence. This pleases the first man, who's been trying for 15 minutes to get somebody to admire his camera.

He holds up the gleaming, chrome-plated instrument. "It's a Flexotax Mark VII," he says modestly. "Got a 135mm $f/3.5$ Sharptar lens on there now, but I got three or four other lenses in here." He pats the gadget bag.

The first man gazes on the wonderful camera, his eyes filled with stars. "Boy," he says, "you must get some pretty great shots with that baby, all right!"

The first man shrugs. "Well, it *is* last year's model. But I can't complain. I hear the new lenses aren't as good." Then, just to be polite, he adds, "Say, what've you got there? Doesn't look too bad, either."

The other man smiles sheepishly.

"It's only a little Imperfecta 72," he says. "No extra lenses." Then he adds hopefully, "But it does have a coupled range-finder."

The first man looks thoughtful. "Plenty adequate, plenty adequate," he says reassuringly.

"Well," says the other man, "you can't beat 'em for color slides."

The other man smiles. "That's right," he says, aiming his telephoto into the sunset. "I guess you can't."

Who Takes Better Pix?

And so the two men go their separate ways, never doubting for a moment who the better photographer is. He's the guy with the fancier camera. They'll never get to see each other's pictures, of course, or even learn whether the other knows how to take a picture. They both might be geniuses with cameras; or they both might be incompetent, hopeless, fumbling idiots.

What these guys remind me of is the hi-fi nut who loves to twirl amplifier knobs but doesn't give a hoot for music, just "sounds." Some camera bugs, who don't give a hoot for pictures and can't tell a good photograph from a modern painting, love to twirl dials on fancy cameras. In what passes for conversation among some shutterbugs, they'll argue for hours over which lens gives the sharpest image, or which camera handles the fastest, or which film works best in what light.

Yet they overlook the most elementary fact of photographic life. It's just this: with two thousand dollars worth of glass and dials, it's perfectly possible to take the most expensive *bad* pictures anybody ever saw. I don't know who spread the false rumor that you need a chrome-plated camera, 12 attach-

ments, and a lens as wide as a picture window to take good photos. Whoever he is I hope he hasn't misled you. Sure, the pros use expensive precision cameras. But pros have to do all sorts of things at high and low speeds, by matchlight and moonlight, and still get pictures that can be enlarged to the size of a magazine page. But you'd be amazed at the things an Instamatic will do in talented hands. You can bet it doesn't snap Ma, Pa, and the kids standing in a line the way George's camera does.

Taking "Good" Pix

In fact, an Instamatic really doesn't "make" the picture at all. It only *takes* it, good or bad. When real, live, flesh-and-blood people look like cigar-store Indians in a snapshot, it's not the camera's fault. There's not a camera on earth that will put a smile on someone's face or get rid of a pole protruding from your girl friend's head. High-priced cameras can't take good pictures any more than high-priced pianos can play good music or electric typewriters write good stories. *Somebody* has to push the button.

So the kind of camera you're using, buddy, doesn't make much difference. But the kind of snapshooter you are, *does.* What you really need to take good pictures are two eyes in fair working order, plus some imagination, patience, and enthusiasm. Unfortunately, you can't get any of these on a trade-in. Yet without them the world's greatest cameras are just lumps of steel and glass. If you have them, you can make a Magic Wand out of a box camera and surprise everybody on the block.

It's too bad George doesn't realize this. A good picture, the kind that makes people sit up and say "gee whiz" (or stronger words to that effect), is made first with your eyes and your brain. The camera is just a convenient tool for recording what you see. But George isn't content to photograph what he *sees.* He has to fool around with it. He has to make people pose and

You can take a good snapshot like this one with **any** kind of camera.
All you need is some imagination and a good "eye" for pictures.

line up and "watch the birdie." And when he finally looks into his viewfinder he doesn't really "see" much of what's there at all. When he's finished his pictures come out dull, flat, and lifeless. Then, because it's the handiest thing around and can't fight back, he blames his camera.

The next time you go out to take pictures, forget about your camera. If it works, it doesn't have to be a fancy, expensive one. In fact, the simpler it is the more your mind is freed to concentrate on the photograph itself—the people, the trees, the houses, the ocean, the mountains, the whole works. Put them together the right way and you may have a prize-winner, no matter what camera you're using. But don't expect the camera to put them together. Without George to manhandle it, it couldn't even take pictures at all.

What Is a Camera?

Did you ever stop to think what a camera is, anyway? It's really such a simple device that you can make a primitive one out of an old shoebox. Clamp the box lid on tight, punch a tiny pinhole in one end, put a little flap of tinfoil over the hole with gummed tape, and you have a camera. If you can figure out how to get film in and out of the box without exposing it to light, you can take pictures with this contraption. They won't be sharp pictures, because a pinhole is no lens. But they'll come out.

In simplest terms, a camera is just a box sealed against light with a hole in one end (the lens) to let just a certain amount of light in. A store-bought camera, of course, offers some nice advantages. You can get the film in and out easily, move the film from one shot to another, allow light to come in for a fraction of a second, focus on specific subjects, and even see your picture in advance in a viewfinder. With some cameras

you can vary the amount of light reaching the film by opening and closing the lens; some allow you to change the length of time the lens remains opened by varying shutter speeds.

The important thing to remember about your camera is that its main purpose is to allow some light bouncing off whatever you're taking a picture of to strike your light-sensitive film. When this happens, you've made an "exposure." If you've been careful, you've also made a good picture.

But *you* make the decisions for the light-tight box. When you point it, you decide whether to tilt it up or down, whether to leave in Aunt Minnie's feet, whether to cut out the old oak tree, whether to make a long shot or a closeup, whether to shoot while Mom is staring into the lens or wait until she smiles at Pop. Your camera, whether it cost fifteen bucks or five hundred, has nothing to do with any of this. It's just a machine like a typewriter—and I'm still shopping for that perfect typewriter that writes great stories!

3. "Did They Come Out?"

People are always asking George if his pictures came out. They don't give two hoots whether they're any good or not. "Hey, George, whatcha got there? Pictures? Great. Did they come out?"

"Sure," George says proudly. "Every last one. Couple on the blurry side . . . Oh, well, nobody's perfect."

The funny thing is that nowadays practically *everybody's* pictures come out. A $12.98 camera's pictures come out just as surely as the ones from a $400 camera, although they won't be as sharp (but you can't have everything for $12.98). Unless you break your camera, cover the lens, shoot in a dark closet, or forget to press the shutter and wind the film, your pictures—miracle of miracles—will come out.

Most new cameras are so fool-proof that a four-year-old can aim one at somebody standing in the sunshine and get a picture. The kid might move the camera, or aim it wrong, or tilt it, but his pictures will come out. What's so great about that? Asking somebody if his pictures came out is like asking him if he can spell "cat." Of course he can. Of course they did.

Nowadays there's a much more apt question you might ask George about his pictures sometime: *"Are they any good?"*

That's a lot harder question to answer than whether they came out. But with most of the technical problems solved for you by the film and camera makers, what else *is* there to ask? Matthew Brady's Civil War photographers could make pictures come out. To do it they had to coat a piece of glass with a light-sensitive solution, put the glass into a camera (in the dark, of course), go outside the tent and take a picture, come back in and process the plate. And they had to do the whole thing within 10 minutes or the film wouldn't be any good. *Their* pictures came out and they were proud of them.

All *you* have to do is slap a roll of film into a fool-proof camera. The drugstore does the rest. So it's time you concentrated on *good* pictures—interesting shots of people behaving the way people do, neatly arranged, good to look at, with

story-telling interest, and so on. Sure, they come out. But what do they look like? In Chapter 8 I'll outline what I believe a good picture is. Meantime, concentrate on learning some of the simple rules for picture-taking. Learn which film to use and when, how to avoid blurred shots, what the drugstore does with your films, and what George does wrong (so that you can do it right).

The camera is a pretty wonderful gadget. You can use it to make a record of your own life and the lives of the people around you. Your snapshots probably will be treasured for generations by your children and their children. Wouldn't it be a shame to leave them what George is leaving—a series of pictures that all look alike, a thousand similar poses that all "came out"?

With a little practice I think that not only will you find that your pictures come out, but also you may find the guy next door looking enviously over your shoulder saying, "Hey, that one's terrific."

George has longed to hear these four words all his life.

4. What the Drugstore Does with Your Film

On a street in State College, Pa., my former home town, there's a large brick building that used to be a supermarket. Nowadays folks buy film and cameras there rather than frozen foods. And in the back rooms employees of the Centre County Film Laboratory spend their days developing and printing pictures. They do it not for fun but for money, and last year they processed more than 100,000 rolls of film, including several belonging to George. No doubt there's a lab like Centre Film in your own area. It's the place the drugstore sends your film.

A film lab processes pictures the way Detroit makes cars: by mass production on an assembly line. I doubt that George cares much what happens to his film between the time he takes pictures and gets back prints. But there are a few things everybody who owns a camera *ought* to know. If you understand what the photo-finisher does in the back room—and what he can't do—you can adapt your picture-taking to his standards; he can't adapt to yours.

How You Get Pictures

Let's say you leave a roll of film in a drugstore in Bellefonte, Pa., one Monday morning. Bellefonte is 10 miles from State College. That evening a driver from Centre County Film Lab picks up your roll with all the others left that day. At the laboratory next morning these rolls join 50 or 100 more for a 15-minute trip through a series of chemicals and a water bath. The raw films become negatives—8, 12, 20, or 36 to a roll. One roll has your name attached.

After they're dry, the negatives go to a printing room where a man sits at what looks like a cross between a juke box and a giant sewing machine. He feeds rolls of film into the machine, which projects a light through each negative onto a roll of light-sensitive paper the way a slide projector shines images

on a wall. Each good shot on your roll becomes an over-size or jumbo print.

The paper prints move through another series of chemical and water baths, then take a trip around a silver-faced drum under pressure. This dries and glosses them. At the end of the line an automatic knife clips each picture from the roll. When your set of prints has been clipped, a man puts them, together with your negatives, into the familiar white or yellow envelope. The envelope probably has your drugstore's name stamped or imprinted on its face.

That evening the driver returns your finished pictures to Bellefonte, where you pick them up the following morning, hoping against hope that they all came out. During the whole trip your film is handled with moderate care and complete efficiency. There's practically no chance of its being lost or damaged.

But notice this: *Your film gets the same treatment everybody else's does.*

This would be fine if everybody used the same films, cameras, and lights on similar subjects. The photo-finisher could adjust his process accordingly, and, presto, turn out perfect prints and negatives for everybody every time. Even George would get better results if the drugstore man knew how his pictures were taken. But the man doesn't know. All he knows is that he sells seven or eight *different* kinds of films called Verichrome Pan or Super-Hypan or something else. They come in 10 or 12 sizes from 126 through 620. They're bought by cute little children, sweet old ladies, and a dozen different kinds of George, many of whom haven't the slightest idea what they want.

The buyers use every kind of camera—Instamatics, Ansco-flexes, Rolleis, Leicas, Nikons, Minoltas, and a hundred others. Some of the cameras are in perfect shape, others broken without their users knowing it. George takes most of his pictures outdoors with the sun coming over his shoulder or indoors with flash bulbs. But some people snap in the shade on cloudy days, others on brilliant sun-dazzled beaches, still others by lamplight in the living room. Some people expose their

films too long, others not long enough.

Take 100 snapshooters and you get 100 different combinations. Yet at Centre County Film Lab all 100 rolls of film go through the same chemicals for the same length of time. And every last one of the hundred snapshooters, including you, me, and George, expects the drugstore to give him perfect pictures every time! The film lab doesn't care how we shot our pictures, though. They're very democratic. They do everybody's the same way.

Getting Good Drugstore Pix

The drugstore develops and prints your film according to a formula they believe will give the best results for the most people most of the time under "average" conditions of light and camera handling. If you want the best possible results from your drugstore photo-finisher, there are at least four things you have to realize and act upon:

1. The photo-finisher develops everybody's film the same length of time no matter how or where it was exposed. Yet development time should be based on exposure. The more exposure a roll of film has had, the less development it needs. The more development it gets, the darker the negatives become. Because the finisher does vary his printing process slightly for each negative, within limits he can make good prints from both dark and light negatives. But for best results you ought to give him good negatives to begin with by making your exposures as close to "average" as you can. Chapter 6 will tell you how.

2. The photo-finisher prints your *entire* negative. He makes no effort to cut out expanses of sky or lawn, nor will he enlarge tiny faces unless you order and pay for real enlargements. He doesn't straighten out crooked pictures. For these reasons you have to set up each picture carefully in your camera's viewfinder. Even a home-darkroom amateur doesn't have to be as careful as you do. He can enlarge *any part* of his negatives. You have to take what you get. Chapter 9 will give you the

To make the most of each negative and get good snapshots like this one back from the drugstore, you must understand how your films are processed. Photo by Mimi Anderson.

lowdown on this.

3. The photo-finisher can't do anything about camera movement, out-of-focus pictures, light streaks on the film, or double exposures. None of these things is his fault, anyway. But people, George among them, often blame him for them. See Chapters 5 and 7 for hints in this department.

4. The photo-finisher, poor man, has no control whatever over *what* you photograph. Over the years he has become pretty immune to typical George shots: phony, cornball smiles; people lined up in a row; TV aerials coming out of ears, and the like. When he does see a roll of interesting, well-composed pictures moving through his machine, his heart leaps up for just a second. But it leaps right back down again. For the next roll is George's.

The rest of the book, I hope, will help you to gladden your photo-finisher's heart. Perhaps this is just a small charity, covered by the cost of your film and not even tax-deductible. But the rewards it offers are great, not only for the man who prints your pictures, but also for you. After all, you're the one who took them.

5. The Trouble with George's Pictures

It's too bad George doesn't need a license to operate his camera the way he does for a car. If he had to pass a test first, he probably would learn what the different settings on his camera mean. As it is, he fumbles and fumes with the camera's few simple controls until his wife sometimes thinks he's going to leave the launching pad and go into orbit. If he drove his car the same way, he'd have cracked up long ago.

But George's pictures continue to come out. Oh, sure, he cuts off a head now and then, and sometimes he blurs a shot badly, but most of the time he makes out okay. This reflects no credit on George, but rather on the people who make nearly fool-proof cameras. Yet some of George's commonest camera errors stem simply from *careless camera handling*. They're the kind of errors no one has to make but practically everyone does at one time or another.

If all the film spoiled each year by poor camera handling were put on one roll, I'm not sure how many times it would wrap around the earth at the equator—but I'll bet it would be the biggest roll of anything you've ever seen. Here are some samples of George's common camera-handling mistakes. In parentheses I've indicated in which chapter you'll find advice for avoiding each error.

But these pictures don't show all the mechanical mistakes George makes. Sometimes he takes pictures with a dirty camera lens, or with part of the camera case in front of the lens. Sometimes he double exposes (two shots on the same piece of film). Now and then he loads his film in the sun or forgets to wrap up the roll tightly and the light leaks under the paper backing. Both Kodak and GAF give away little pamphlets showing examples of all of these common picture-destroyers. You can have one for the asking at your drugstore or camera store.

There's *another* set of bad habits George has acquired which often spoil his pictures even when they're sharp, well exposed, and lined up straight. These habits have to do with

Way too much light hitting that film. Easy to avoid. Either change exposure or else change film. (See Chapter 5 for suggestions.)

Recognize "camera movement" when you see it? George jabbed at the shutter on this one. (Chapter 6 shows you how to hold a camera steady.)

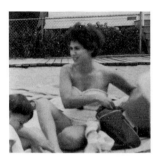

Background's sharp. Why not the girl? George took this one out-of-focus. No excuse. (See Chapter 6.)

What was George thinking of here? You can't tilt the camera without tilting the picture. (Chapter 11 gives some advice on straight shooting.)

You can't make movies with a box camera. (But Chapter 15 shows you how to photograph action.)

Commonest George shot. He stood so far back that his friends are lost amid driveway, trees, poles, and clutter. (Chapter 8 gives the simple remedy.)

Pretty typical. What kind of expression is that for a pretty girl? People can be made to **act** like people. (Chapter 9 shows you how.)

What's this a picture of? Your guess is as good as George's. Every picture ought to have an **idea**. (See Chapter 10.)

Where did George's "fantastic" view disappear to? (Find out in Chapter 13.)

the way George "sees" a picture. They have to do with *what's in front* of his camera when he decides to snap. About nine times out of ten George's ideas and subject matter are dull, disorganized, dreary and drab—four "D's" that have nothing to do with dimension. It's in taking these pictures that George wastes more film, gets less satisfaction, and receives less appreciation than any man alive. And no wonder. Here are some samples of George's pix in "4-D."

In the following pages you'll find ways to get around all of George's bad habits. If you're a beginner in photography, you're lucky. You don't have any bad habits—yet. You can start from scratch to see pictures *as* pictures without having to unlearn all the things George specializes in. Don't be cocky, though. Most of the snapshots you've ever seen look something like those above. Probably you don't realize how easy it is to take better pictures than George's. Maybe you don't realize that there *are* better ones. Read on.

If you *have* been taking pictures and some of yours resemble some of George's, don't despair. Mine used to look like George's, too, which makes me an authority on bad pictures. To take good pictures you have to break bad habits. And the best way I know of to do this is to form *good* habits, for everything from camera holding to picture-framing. The trouble with George's pix is that they're terrible. But yours don't have to be.

6. "What Film Does Everybody Else Use?"

"Gimme a roll of film," George tells the drugstore clerk.

"Color or black-and-white?"

"Oh, color," says George.

"Okay," says the clerk, "but do you want Kodachrome or Kodacolor."

"Darned if I know," says George. "What's the difference? I just want to make color snapshots."

"Well," says the clerk, "the first thing you have to decide is whether your making slides for a projector or prints for your album."

"Like I said," George says, "snapshots. Prints."

"Okay," the clerk says. "The next thing is size. What kind of camera you using?"

George tells him.

"In that case you need 126 cartridges with 12 exposures to a roll." He hands over a roll of Kodacolor.

"And don't forget to follow the instructions he says," re-

ferring to the data sheet that describes how to use the film under varying light conditions.

George nods his head.

At home George loads the film into his camera and throws the data sheet into the wastebasket, as he always does. That weekend the family leaves for a summer vacation on Cape Cod. When they stop by a roadside rest for sandwiches and sodas, George snaps his wife and the kids (who stop eating "so as not to spoil the pictures"). When they reach their little cabin in the woods, he takes more pictures of the family standing outside, luggage in hand—although the hour is late and the sun nearly to the horizon. "Still plenty of light," George mumbles, being careful to set the sun over his left shoulder, unmindful of the long shadow he is casting across Mrs. George's face.

"By golly," George says, as he staggers into the house with suitcase in one hand and camera in the other. "Used up half a roll already. That's vacation for you. You get carried away."

ON THE BEACH. Next day they go to the beach where the sun dances from every wave and glistens off the sand. Puffy clouds float overhead, and the family's glad to find relief from the early forenoon heat by taking a fast dip in the water. George squints his eyes against the sun.

"Perfect day for pictures," he says. "Okay, everybody line up for the first one."

That night, on the way back from the beach, George drops the film off at a drugstore. "Some great ones there," he tells the clerk.

Three days later George picks up the prints and takes them home. The family looks. They pass the pictures from hand to hand, poring over each one just as if it weren't exactly like last year's, except my, how everyone's changed. And isn't it fun to have jumbo prints in color, for a change, instead of slides, which you can hardly see without a viewer.

"Yeah," George says. "They cost an arm and a leg, too."

"Daddy," George, Jr. says at last. "Some of the shots came out great. But look at the ones in front of the cabin. They're so dark. And red. I don't get it. It's like all in the shadows."

"Yes, dear," adds Mrs. George. "And the beach scenes. They seem so . . . well, so *bright*." (In fact they are washed out pastels. Not at all bright and lively like the properly-exposed pictures.)

"Hmm," George says, his face growing red. "Can't figure it out. I took 'em all exactly the same way."

"I like color slides better," George Jr. chimes in.

"If you're going to spend that much money, dear," says Mrs. G., "the least you can do is . . ."

George doesn't hear her. "I think I'll go fishing," he says, reaching for his rod and reel.

READ THE DATA SHEETS. The moral to this cautionary tale is succinct. Read the data sheets. Nothing I can write here will explain better, more clearly, or more appropriately how and when to use the film you buy. The manufacturer has taken great pains to explain how his film should be used for best results. He gives you a free short technical course with every roll you buy.

WHICH FILM TO USE. However, the first decision you need to make is which film to buy. Black-and-white or color? Negative film or slide film? Fast film or slow film? How do you decide? The differences are not simply ones of format or presentation method. Films vary enormously in the kinds of things you can do with them. They also vary in cost. On the following pages is information that can help you decide when to buy which type of film.

How Film Works

To understand George's predicament, you have to know something about film. Film is made by coating a flexible plastic base with a silver solution sensitive to light. When light strikes a piece of film it tends to darken the silver grains. Bright light reflected from sunny faces, white shirts, and clear skies causes considerable darkening. More subdued light reflecting from dark clothing, trees, and grass darkens the film less and may even leave it almost transparent. Take out a

negative for a minute and examine it. Where are the dark areas? The light ones? Can you see how *varying* amounts of light striking a piece of film cause varying densities in your negatives?

George's beach pictures were *overexposed.* That is, *too much* light struck his film, causing it to become dense and black as the contrast between his light areas and dark areas decreased. Meanwhile, *grain,* caused by clumping of the light-sensitive silver particles, created the mottled effect Mrs. George calls "spotty stuff."

As far as George is concerned, light is light. He knows you need *enough* light—which means the sun or a flash bulb—to take pictures. But how can you have *too much?* What George doesn't know is that different films require *different* amounts of light to make good negatives.

Each type of film in the local drugstore has a different sensitivity to light; each one is made from a different material; and each one produces a different final product. There is, however, an easy way to know which film makes what kinds of pictures—whether black-and-white prints, color prints, or color slides. The formula is as follows:

Any film ending in *chrome* (for example, Kodachrome) produces color slides, which require a projector or inexpensive hand-viewer.

Any film ending in *color* (for example, Kodacolor) produces color prints, which can be mounted in an album.

Any film with *pan* in the name (for example, Verichrome Pan) produces black-and-white prints. Pan means "all." Panchromatic films are sensitive to all colors, translating them into various shades of white, black, and gray.

In addition, each of the above types of film is made in a variety of sensitivities to light. Kodachrome II, for example, is less than half as sensitive, or "fast," as Kodachrome X. Likewise, High-Speed Ektachrome is more than twice as "fast" as Ektachrome X; and Tri-X Pan is more than three times "faster" than Plus-X Pan. Fast films are used to make pictures in situations where the light is less than normal, such as in the late afternoon on a winter's day.

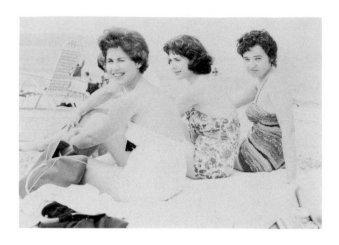

Films usually used in box cameras at the beach often give washed-out pictures like this one caused by over-exposure.

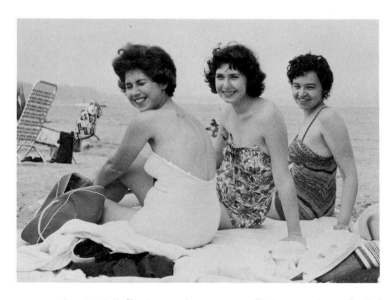

Panatomic-X film in your box camera will give you sharp, detailed prints of pix made in extremely bright light.

What Does Film "Speed" Mean?

A film's sensitivity to light is referred to as "speed." When people talk about "fast" or "high-speed" films, they mean films extremely sensitive to light. Tri-X Pan is a very fast film. In this jargon, then, Panatomic-X, which comes in several sizes, is a "slow" black-and-white film. Film speed is expressed by an ASA or exposure index number. The number tells you the film's relative sensitivity compared with other films. Hence, Panatomic-X (ASA 32) is about one fourth as fast as Plus-X Pan (ASA 125). It takes four times as much light to make the same exposure with Panatomic-X than with Plus-X Pan. What difference does it make? Why use a "slow" film at all?

The main reason is "grain," Mrs. George's "mottled" effect. The slower a film, the finer is its grain. Fine-grain film permits greater enlargements of small negatives without mottling. If you don't intend to enlarge your negatives, you need not worry about grain.

Common Films

Below is a list of common films and sizes, and the conditions under which each might best be used.

COLOR PRINTS

Kodacolor-X (ASA 80) Good all-purpose film for non-adjustable as well as adjustable cameras, both with and without flashbulbs (use blue bulbs). Negatives can be enlarged.

COLOR SLIDES

Kodachrome II (ASA 25) Sharp, "colorful" slide film, excellent for beach, snow, and other bright scenes.
Kodachrome-X (ASA 64) Good for gray days, or in the shade. Allows higher shutter speeds with adjustable cameras.

Ektachrome-X (ASA 64) Good in low light situations. Tends to bring out blues more than Kodachrome-X. Some people prefer this color balance to the "technicolor" feeling of Kodachrome-X.

High-Speed Ektachrome (ASA 160) A fast slide film, good for action shots indoors or out in dim light. Available in 126 cartridges for Instamatic-type cameras, but watch out! Under normal sunlight it is easily overexposed.

BLACK-AND-WHITE PRINTS

Verichrome Pan (ASA 125) Most common all-purpose snapshot film. Fast speed allows good pictures in the shade or on cloudy days.

Plus-X Pan (ASA 125) Fast, fine-grain, allows sharp pictures suitable for enlarging.

Panatomic-X (ASA 32) Slow, extremely fine-grain film, for very sharp pictures and maximum enlargement without losing details.

Tri-X-Pan (ASA 400) Very fast film, excellent for existing-light pictures, or with very high shutter speeds to stop fast action.

How to Set Your Adjustable Camera

Your adjustable camera *must* be set according to the speed of the film you are using. You can't use the same shutter speed *and* lens opening (*f*/number or "aperture") for every kind of film. To help you make these settings, film-makers include a little slip of paper with each roll. George usually throws it away. Don't you do it. Instead, check the recommended exposures and do one of two things:

1. If you own a light meter, set it for the ASA or "exposure index" listed for your film. For example, if you use Plus-X film, set your light meter for ASA 125.

2. If you have no meter, follow the suggestions for "bright sun," "hazy sun," "cloudy bright," and so on.

This way, under most conditions, nearly all cameras and films will give you good negatives with drugstore development. Nevertheless, it is possible your camera shutter may be slow, or your film may be slightly underrated by the manufacturer to allow a "safety factor" against underexposure. Either way, you will soon know it because, by using standard exposures, your pictures will be overexposed. The negatives will be dense and the prints will be grainy, washed out, or both. When you get a roll like this, don't repeat your technique. The next time, instead, cut the recommended exposure in half. You can do this two ways:

1. By setting your camera at *half* the recommended shutter speed for a given light condition, or at the next *higher* aperture number. If the slip of paper suggests 1/100 sec., use 1/200. Or, as an alternative, if the paper recommends $f/8$ at 1/100 sec., use $f/11$ at 1/100 sec. to correct overexposure.

WHAT IS ASA? Unless you own a light meter or plan to buy one, you might as well skip this section. It'll probably confuse you. If you *do* own a light meter, and have been wondering what "ASA" and "exposure index" mean, I will try to unconfuse you.

ASA or exposure index (sometimes called film-speed rating) refers to how sensitive to light a film is in relation to other films. ASA stands for American Standard Association, an outfit which sets up the ratings. When you hear people talk about "ASA 400" or "ASA 2000," they don't mean 400 or 2000 of anything you can see, feel, or count. They're talking about the *relative* sensitivities of films under different conditions. So a film rated as ASA 2000 will give you printable negatives in only one fifth as much light as a film rated at ASA 400. Ambitious photographers who develop their own film can do this by increasing development time and using selected formulas. At the drugstore your film gets processed exactly like everyone else's. The trick, then, is to change the recommended

ASA just enough to improve your negatives under standard conditions.

CHANGING ASA. So, when you read on the little film strip

EXPOSURE INDEX: Daylight 80 Tungsten 64

this simply means that this film is less than half as sensitive to light as a film whose slip reads

EXPOSURE INDEX: Daylight 200 Tungsten 160

To make the *same* exposure on the second film takes less than half as much light as the first film.

What happens when you set an exposure index on your lightmeter? You're simply setting the meter's scale to give you shutter and aperture readings for whatever sensitivity your film has.

"Tungsten," by the way, refers to artificial light—lamplight in particular. In practice there's so little difference between tungsten and daylight ratings for black-and-white films that you can set your meter for either and get good results. Remember, to cure overexposure, you can safely double the ASA rating on any film you use, except color films (where you should stick to published ratings), without any change in processing. Your picture quality should improve. Color is a different story, and changing from daylight to tungsten or vice versa may also require the use of filters. Check the film slip.

But the *content* of your pictures, alas, depends not on films, ratings, cameras, or light meters, but on your own sharp eye and nimble brain. So on to the next chapter.

Sunlight is no longer necessary for good snapshots. Picture of Nina (right) was made outdoors in the shade, while Bobby (above) was snapped indoors by windowlight. Plus-X film, rated at ASA 200, was used for both pictures. Photos by Betty Nettis.

7. "Why Are They So Blurred?"

George once had a camera with a little button marked with a "B" on one side of it and an "I" on the other side. His instructions told him to turn the button to "I" for outdoor pictures and "B" for flash pictures indoors. He set the button on "I" and took the first roll of Mrs. G. and the kids in the park. ("Not bad," he said later. "They all came out.") Then he tried his hand at flash pictures. These all came out, too, though they left something to be desired as pictures.

George's third roll really shocked him. It was taken out-of-doors in bright sunshine on a perfect, cloudless day. There wasn't a sharp picture on it. Not one.

"Why so blurred?" George demanded. He laid the miserable looking prints on the glass counter in front of the clerk. "Every last one of them, blurred all to blazes."

The clerk had seen it before. George wasn't the first guy to do it and he wouldn't be the last. "My friend," the clerk began patiently, "you have a little camera with both 'I' and 'B' settings on it. Right? Well . . ."

George never mastered the "I" and "B" settings. Fortunately, he doesn't have to anymore. In the last few years cameras have been developed with internal flash synchronization. That means the shutter opens and closes in time with the flashbulb, making it unnecessary to hold the shutter open a fraction of a second longer. (George's old pictures blurred because he moved his camera at the "B" setting instead of switching back to the "I"—instantaneous—shutter setting.)

Nevertheless, you can still take blurry pictures if you do any one of the following things:

1. You let your lens get dirty or smeared.

2. You may move the camera during that fraction of a second when the shutter is open.

3. You may be out-of-focus—that is, your camera may be set at a distance greater or less than your subject actually is.

4. You may be too close for the capacity of your lens, or too far from part of your subject for your settings.

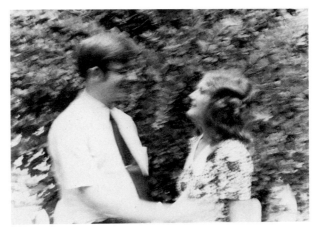

Camera motion at the instant of exposure gives you a blurred shot.

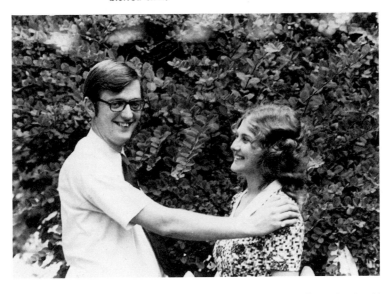

Here's the same picture made with the camera held steady. Photos by David Willis.

Let's consider each of these common mishaps in turn and prescribe simple remedies.

Keep Your Lens Clean

George never checks his lens. It has greasy fingerprints all over it, and the grease traps tiny particles of dust. The fingerprints and particles don't show up in his pictures. They simply block some of the light entering his lens, which produces uneven blurry appearance. The simplest remedy for a dirty lens is to wipe it with lens tissue, not the kind you use for eye-glasses. You can also use a lint-free soft cloth, or a shoe-cloth, however, avoid using your shirt or skirt. Frequently you add lint while eliminating the fingerprints. Worse, a hard particle trapped in the fibers of your clothing could scratch your lens. This doesn't happen often, but it could. Don't let it happen to you.

Don't Move Your Camera

You can blur a picture with any camera if you move it at the instant of exposure. Camera movement spoils more pix than any other single error. Yet it's the one error everybody can avoid simply by bracing his camera properly.

George, who holds his camera out in front of him as if it were about to explode, often blurs his pictures. Not only does he hold it wrong, but he jabs awkwardly at the shutter button too, wobbling the camera during the 1/50th of a second when it must be held still.

How to Hold It. To avoid camera movement, you have to (a) brace the camera as rock-steady as you can and (b) *squeeze* the shutter button the way a crack rifleman squeezes a trigger. You can't do either of these things if you're used to holding your camera with elbows flapping in the breeze like the wings of a chicken.

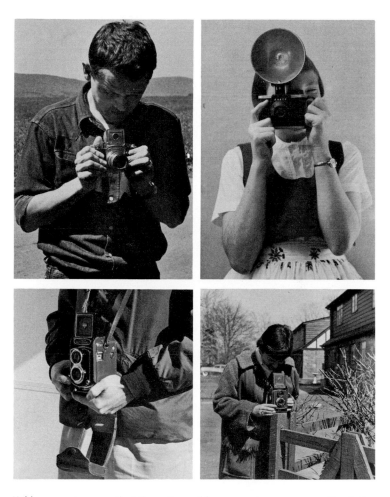

Hold your camera so that it can't possibly move when you press the button. Note how these people keep their elbows close to their sides.

In the accompanying pictures are some people holding their cameras for maximum steadiness. Notice in each case that the camera is supported at three points, usually cheek and elbows braced against sides. A waist-level camera should be held tight against your waist with your elbows tucked in.

You can also pull your neck strap taut against your neck for extra support. If you have an eye-level camera, hold it tight against your cheekbone and tuck in your elbows.

Then follow these simple rules:

1. When standing, keep your feet apart, one slightly ahead of the other. Shoot from a crouching position the same way.

2. Take a deep breath and hold it for an instant.

3. Now *squeeze* the shutter gently. To avoid jarring try to press it about half or three quarters of the way in *without* clicking it. Apply slow, gentle pressure. How far can you go without snapping? Now you ought to be able to trip the shutter with the tiniest movement of your finger. The camera won't move.

In fact, if you get your unloaded camera out right now and practice this sequence a few times, you ought to be able to kiss camera movement goodby for good.

HIGH SPEEDS. A tip for adjustable-camera owners: popular opinion has it that you use high shutter speeds (say 1/300 or 1/500 sec.) only to "stop fast action," like running horses or speeding autos. As is often the case, popular opinion needs some revision. Certainly you can use high speeds to freeze movement. But—and this is important for sharp pictures—you can *also* use high speeds to guarantee sharpness in *any* snapshot.

Let me qualify that statement: any snapshot where your subject is a person or a few people and not a block of scenery usually will benefit from higher shutter speeds. Most camera books advise you to use a "basic exposure" of, say, 1/100 sec. at $f/11$. But why use 1/100 for a routine snapshot if you can use 1/300 at $f/6/3$? If jarred slightly, your camera will move *three times* as far at the lower speed as it will at 1/300 sec. The higher speed usually pays off in much sharper pictures —as long as you open your lens wide enough to compensate for reduction in light. And of course the higher speeds will minimize subject movement too. One thing, though. At high shutter speeds and wide apertures, you must focus your camera carefully.

Focusing

You won't say goodby to blurred pictures so easily unless you're also precise about *focusing*. With a box or other fixed-focus camera it's easy. Just don't try to take pictures any closer than 6 ft from the camera (unless you have a special closeup attachment).

With an adjustable camera you have to focus on every shot or risk out-of-focus fuzziness. Your camera may have only a rangefinder scale on the lens with numbers ranging from about 3 ft to infinity. Focus this camera by guessing the camera-to-subject distance and setting the scale accordingly. As long as you shoot out-of-doors in good light (where your lens aperture will be small), your pictures should remain in focus if you're a half-decent guesser of distances.

Many 35mm cameras feature a rangefinder with a split image; others, the reflex types, allow you to focus directly through the lens. Twin-lens reflex cameras use a second lens strictly for view-finding and focusing. Learn where and how you set it carefully before each shot. Nothing's more discouraging than to take a perfect shot of your best girl—perfect in every way, that is, except that it's out-of-focus. (Not only do you lose the picture but you might lose the girl!)

Depth of Field

While we're on the subject of focus, we might as well discuss its brother idea, depth of field. (By the way, you need to understand it only if you own an *adjustable* camera. Box camera people can skip this section unless they're curious.) This was one of the things that made George give up his adjustable camera. People were always telling him about depth of field and he never had the vaguest notion what they meant—even with all the charts and diagrams.

Depth of field refers to how much of a picture will be in sharp focus when your camera is set for a particular lens open-

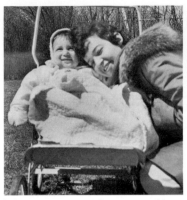 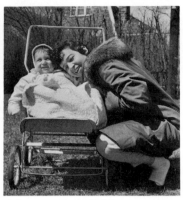

A box camera too close to a subject gives you an unsharp picture.

A box camera held 6 ft or more from its subject should give a picture in focus like this one.

ing or *f*/number and focused at a particular distance. The *wider* the opening (the smaller the *f*/number, this is), the *smaller* the range of sharp focus at a given distance. Let's say you take a picture of Aunt Minnie from a distance of 5 ft with your twin-lens reflex camera. She's standing in the sun, so you set your camera at 1/250 at *f*/11 (with Verichrome Pan film). At *f*/11, focused at 5 ft, a typical twin-lens reflex camera will give a sharp picture from 4½ to 5¾ feet. Here's what this means to Aunt Minnie. If you focused on the tip of her nose (5 ft), anything up to 6″ in front of her nose and 8″ behind it will be sharp. Anything nearer or farther from the camera will become gradually more blurred. So if Aunt Minnie's pointing her finger at the camera, and her arm extends to within 3 ft of your lens, expect the arm to be out-of-focus. It's *out* of the depth of field, or range of sharpness. On the other hand, if there's a barn 50 ft behind Aunt Minnie, it too will be blurred and out-of-focus for the same reason. It's too far back. In fact, Uncle Manny, standing just a foot behind Aunt Minnie, will look somewhat unsharp too, even in his new suit. He, too, will be slightly outside the range of sharpness.

CHANGING DEPTH OF FIELD. There are two ways to change the range of sharpness in a picture.

1. Move nearer to or farther from the subject. The *farther* away you get, the *more* range of sharpness you get, even if you don't do another thing. In the picture of Aunt Minnie, you could increase the range simply by moving back to 8 ft. Now you'll get a sharp picture from 6½ to 10 ft, a total coverage of 3½ ft, where you only had 14″ before. In this picture most of Aunt Minnie's extended arm and all of Uncle Manny will be sharp.

2. The second way to change range of sharpness is to widen or narrow the lens aperture. The smaller the opening (or *higher* the *f*/number), the *greater* the range of sharpness. Back to Aunt Minnie for a minute.

Let's say the sun goes behind a cloud. To take a picture now you have to *double* the amount of light entering your camera because there's only about *half* as much as from the bright sun.

So, instead of 1/250 at *f*/11, you set your camera for 1/250 at *f*/8. Focused at 5 ft, you now have a range of sharpness of less than a foot, even though you had 1¼ feet before. If you change your setting to 1/500 at *f*/5.6 (*same* amount of light entering camera as 1/250 at *f*/8), your range of sharpness would go down *still more* to about 7″—barely enough to get the buttons on Aunt Minnie's blouse and the top of her head perfectly sharp. Focused at *any* distance, your range will go down if you open your lens wider.

On the other hand, make your lens opening *smaller* and you *increase* your depth or range of sharpness. If you change your settings again to 1/60 at *f*/16 (*still* the same amount of light), your range at 5 ft will go *up* again to about 1¾ ft, enough to get Minnie and Manny. And if the sun comes out again, allowing you to close down the lens by one *more* stop to *f*/22, your depth increases still more. At *f*/22, focused at 5 ft, you get a sharp picture from 4 to 6¾ ft, a total of 2¾ ft of sharpness. Remember you only had 7 *inches* at *f*/5.6.

So WHAT? What's depth of field good for? There are two basic uses to which you can put your knowledge of depth. Each will help you make better pictures.

When your camera is focused on close objects, as it is on Sally in this shot, the depth-of-field will be relatively small. Mary is out of focus.

Move the camera back, though, and both girls are sharp. At **any** aperture, range of sharpness increases as you move back. Photos by David Willis.

Only Bill is sharp with the camera set at $f/2.8$. Small depth-of-field leaves Ann out of focus.

Change the aperture to $f/16$ (and alter shutter speed accordingly) and both Bill and Ann are sharp. Depth-of-field has increased though distance remains unchanged.

1. *To throw backgrounds out of focus on purpose.* Move close to a subject, open your camera aperture, snap a picture and you can be sure that your background, no matter how cluttered, will be out-of-focus and fairly harmless. This is a fine way to emphasize the faces of cute babies and pretty women as well as handsome men.

2. *To guarantee sharp focus over great distances* in shots of scenery, city streets, the old homestead, or whatever. Obviously what you do here is set your camera for its *smallest* aperture (highest *f*/number). Then move back far enough to get everything sharp you want to be sharp. Many cameras have depth-of-field scales printed right with their rangefinders. You'd be wise to get out your camera's instruction book and learn to use the scale. Remember that depth of field, like a saw, hammer or chisel, is simply a *tool.* Having a little of it or a lot in a picture is no greater trick than driving a nail straight. The idea is to *use* depth of field to make good pictures. My friend George won't be bothered. Will you?

Wide-aperture pictures at short distances will throw backgrounds out-of-focus and emphasize faces as in this shot of Mike.

8. What Does a "Good" Picture Look Like?

Photographers, like fish, tend to run in schools. Some specialize in birds or animals, others in portraits; some photograph scenery, others people. The so-called "serious" photographers love to wrangle over what makes one picture good and another bad.

The average snapshooter needn't worry about the endless haggling among people who consider photography an art or means of self-expression. I think the rules for good snapshots are fairly clearcut and easy to follow. Here is my version:

1. A good snapshot is **simple.** It deals with *one* idea.
2. A good snapshot **tells a story.** If there are people in it, they are *doing* something besides posing.
3. A good snapshot is **easy on the eyes.** Whatever items the picture contains are arranged pleasantly, like furniture in a neat room.

Accompanying this discussion are a few of what I would call "good" snapshots. Look at them for a minute. Notice that each one treats only one idea; nobody has to tell you what or who the subject is. Notice that the people are doing something: a mother laughs at her young son; a pretty girl eats an apple; a bride and groom smile happily. Notice that the Japanese pagoda is framed by trees and that the picture seems to have three dimensions.

These snapshots—simple, interesting, good-to-look-at—might have been made by anyone with a camera. Do your own snapshots look even remotely like these? If they do, you're probably on the right track to that special Never-Never Land reserved for people who care about snapshots. If they don't, I hope the next several chapters will help you get on that track.

Look at Magazines. Have you ever looked closely at magazine pictures? Probably you have if the subject happened to be a famous athlete or entertainer. But how about the everyday pictures of less-than-beautiful people? *Pagaent* and

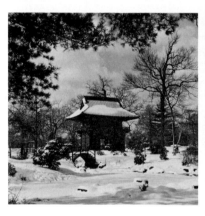

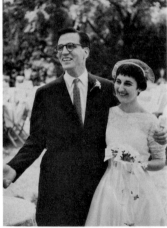

Some examples of good snapshots. Each is simple, interesting, and good to look at. Top and center left photos by Joseph Nettis. Lower right by David Willis.

other picture-oriented magazines often print little picture stories on the most ordinary things in the world: a boy's first haircut; what it's like to be three years old; a family's summer camping trip; some city folks on a visit to a farm.

None of these stories is beyond the reach of George's camera. His family isn't much different from half the families you run across in some magazines (which is why the magazines use them to begin with). But in the George family album you see one stick-in-the-mud shot of blank-faced people after another. They look pretty different from those in the magazines. Why? Well, the magazine photographer usually *says* something about the people in his pictures—they're happy, busy, talking, playing, working. He tells his stories with simple subjects and simple ideas. His pictures usually look good because they include patterns or lines and shapes or backgrounds which help to set off the people. In short, he usually applies the three rules we started with. Don't take my word for it. Pick up an old copy of *Life* and study a picture story for a few minutes. Do the shots meet the three tests? I'll bet most of them do.

George, of course, is no pro. He hasn't taken thousands of pictures, and he doesn't earn his daily bread with a camera. So he's not compelled to learn to use it right or starve. Nonetheless, he *does* photograph people. I think his big trouble is that he doesn't even *try* to tell anything about them. And he never notices things like trees growing from heads or garbage cans lurking behind wife and kids, or people too far away for their faces to be seen. In the back yard, on the beach, at Niagara Falls, or traipsing across Europe, George takes the same bad pictures over and over again. He simply lines up people and snaps, and that's it. Any wonder his shots look so much alike?

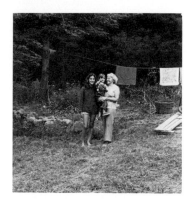

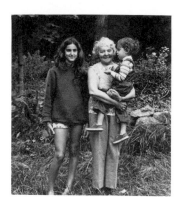

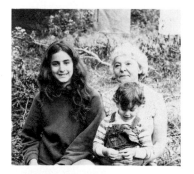

This series shows how you convert a typical George effort into a good snapshot. Photos by Joe Weisbord.

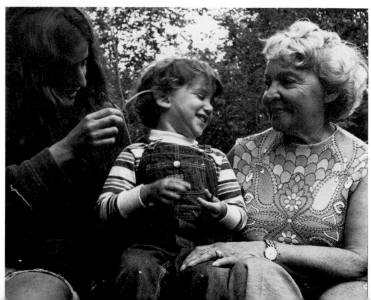

Taking a Good Snapshot

Of course George *could* give his snapshots some life and eye appeal without fancy props. Let me show you how. Above and to the left is a series of pictures. It starts with a typical George picture, and it ends with what I could call a good one. Yet the same people appear in each, and they never move more than 10 ft the whole time. This series, I think, illustrates where good snapshots come from. Study it a minute and see.

The usual George effort shows lots of ground and trees but very little Sister, Grandmom, and baby. It's the kind of picture you'd find by the dozens in practically any snapshot album of practically any home in America (or Japan or France, for that matter). And, frankly, it's terrible. The most obvious way to improve it would be to move the camera closer to the people. If George were taking the shot now, he'd probably come up with something like the second shot. At least the faces show. But what about the tree sprouting from Grandma's head? And what's everybody doing, anyway? Simple picture? Sure, but not very beautiful or interesting. We have to do something with the women and the baby if we're ever to make this picture look good. Perhaps sitting them down on that little wall would help fill the square viewfinder a bit better and make a more interesting arrangement. How about the third picture? Certainly it's a nicer shot than the other one, but oh, those deadly poses! The two women look as phony as three-dollar bills. And why shouldn't they? Nobody *ever* sees them looking that way in real life, except maybe George the photographer.

Yet here we have the makings of a good snapshot. First, let's change the camera angle so that heads and trees don't run afoul of each other. Now let's have Sister and Grandmom *really* doing something—something, for instance, that they might do if no one were taking their pictures. Let's ask them to play with the baby. Because they like to do that anyway, they won't have to pose or fake. Result? The final picture, a neat snapshot of Sister, Grandmom, and baby behaving the

way people usually do. Which picture would you want in *your* family album?

As you can see, you don't pull good snapshots from a magician's hat. You go out and make them. You don't have to take pix like the first three at all. Do those in your head. Or do them in your viewfinder. But don't take them. No rule says you have to snap a picture that doesn't look right to you—a picture that isn't simple, interesting, and good-to-look-at. A good picture shows a small bit of life's passing parade, the faces of people you want to remember, the things you used to do. A good picture stirs fond memories years after it was taken, because it tells you something about its subjects. A bad picture tells you more about the photographer than anybody else.

9. The Camera Is *Not* Like Your Eye!

Somebody once told George that the camera works "like your eye." At least he thinks that's what they said. Anyway, he figures that he ought to be able to photograph anything he can see as long as it's in the sun. But to this day he can't figure out why so many of his printed pictures look different from what he saw when he snapped them.

"Remember the pictures we took in the park last week?" he asks Mrs. George.

"Sure do," she says. "They were wonderful—if they came out."

He shoves some prints under her nose. "Well, look at these."

Mrs. G. looks. "They're very nice, dear, but why are the faces so small? You can hardly see Junior and me at all."

George picks out one picture. "That's nothing," he says. "How about that sensational view from the top of the hill? Look at this. You can't make out a thing down in that valley."

See the Way Your Camera Does

George, who thinks the camera works like his eye, has been fooled again. For the pictures that look one way to his eyes look quite a bit differently to a camera. And George will never learn to take good snapshots until he learns to *see the way his camera does*. Although a camera's lens and the eyes' pupils admit light rays in roughly the same way, they "see" differently because a camera is just a hunk of metal and plastic. Behind each pair of real eyes is the brain of a human being. Your eyes see the world as a kind of indefinite oval, the field of vision. You can take in every person, car, sign, and storefront on Oak Street at a glance. But your camera can't. It picks out a certain rectangular area—and chops off the picture at top, bottom and sides.

Moreover, your eyes see only what your mind wants them to see. On the street they see the people or cars or stores that interest you, and they ignore everything else. Some men remember every detail of a pretty girl's face but not the color of her dress. A woman may remember every last detail of the dress. But a *camera* would see not only the girl's face *and* dress but also the chair she was sitting in, the flowers in a vase behind her, the curtains on the window, and the pattern of the rug. It's not the camera's idea to make beautiful women, children, and furry animals the most popular picture subjects. It can't tell a pair of shapely legs from a couple of sycamore saplings.

GEORGE IN ACTION. Let's follow George to the park. "Get over there by that old statue," he tells the kids. "I want to get a shot of you." Then he backs off 15 or 20 ft "to get everything in." How does George see this scene? He sees the kids life-size in three-dimensions and full color; he can make out every detail of their faces. Ditto the statue. To his eyes it's a fine shot. But he doesn't realize that he's seeing *selectively* and ignoring everything but the kids and the statue. Not so his camera.

No wonder George's prints, just back from the drugstore, look different from what he saw. A camera at 20 ft sees a lot of stuff unnoticed by most snapshooters. All that grass in front of the kids, for example. Hmm, George didn't plan on that. What about that chunk of sky behind and to both sides of the statue? Didn't figure on that either. And the kids themselves? Well, look at those faces—just two tiny circles with hardly anything more than dots for eyes, nose, and mouth. George thought he was taking a picture mainly of kids. His camera had other ideas, because the kids take up only a small part of the picture area. His eyes thought they were the whole show. And that, Mrs. G., is why the faces are so small.

George's eyes fool him in other ways, too. There was the time he took a picture of some neighbors standing in front of an old willow tree in their yard. One of the branches seemed to grow out of Tom's head. "I didn't see it," George said later, laughing, and, as a matter of fact, he didn't. But his camera

did. It doesn't know the difference between Tom and a willow branch, and what's more, it doesn't care. You've probably seen variations on this theme—poles growing out of heads; railings passing through necks. If you sometimes take pictures like these it's because you're seeing what you want to see. It's too bad your camera isn't so particular.

Study Your Viewfinder

What you have to do first before you can take good pictures is *learn to see the way the camera does.* It's not so hard, but few snapshooters bother to do it. This seems surprising because the camera's manufacturer intended you to see that way. In fact, that's why he put a *viewfinder* on your camera. A viewfinder isn't just a little eyepiece for lining things up. It's probably the closest thing to a real picture-window you'll ever look through, for it gives you an advance peep at your finished shot—before you click the shutter.

Whatever you see in your viewfinder appears in your picture. What you *don't* see, won't appear.

I can hear you already: "Sure, everybody knows that." What you mean is everybody *should* know it. But do they? My friend George certainly doesn't; and if you think he's the only one, go through your neighbor's photo album sometime (or perhaps go back and look at your own).

A viewfinder tells you how much earth and sky are in your picture and where the trees and poles stand in relation to the people. If there's a garbage can behind the baby's head, the viewfinder will tell you so. If the people take up only a small part of the picture—if their faces will be dots in the print—the viewfinder gives you the word in advance. It doesn't matter how hard you wish that what your eyes saw will be the only stuff in the finished print. The print can only contain what your eyes see *in the viewfinder.*

If there's a secret to seeing pictures the way the camera does, it's just this: don't just look into the viewfinder, *study* it. You can't just center somebody up and make sure his head

When you don't study the viewfinder you get pix like this one. Your eyes see only the people, but the camera sees everything in front of it.

Studying your viewfinder will lead you to move in close, simplify backgrounds, and show the faces.

shows. You have to make your eyes rove from your subject (what they *usually* see) to *all* objects in view. Check from top to bottom and side to side. Look at the background and the foreground and try to see people as being in front of this and behind that. It doesn't matter how far in front or behind. As long as they overlap, people and buildings or people and poles or people and tin cans will blend together into a flat picture.

WHAT DO YOU SEE? Does a clothesline seem to run through Aunt Martha's ears? (I once took one like that and one is enough.) Does the apple tree seem to grow out of Susy's head? Give the tree as much attention as you do Susy (which is what your camera will do). Is the bottom half of the picture mostly grass lawn or sidewalk? Maybe you're standing back too far. Move closer and watch where the pavement goes. What's on either side? Do you *want* that jumble of houses on the right? If not, maybe you can substitute a plain fence by moving to one side or the other. Is there a wise little kid trying to spoil things by riding his wagon into your nice, simple background? See him first in the viewfinder. If you don't, don't worry about him. Faces too small? How big do they look in the viewfinder? How much of the finished picture will they take up? How important are they, anyway, in this particular shot? Want more of the house in? Or less? The viewfinder tells you how much you have, so don't ignore it.

With a little practice you can study a picture in your viewfinder in much less time than it takes to read about it. Your mind works something like this: *Subject?* Can I see the faces? Are they animated? Is the story interesting? (See next chapter.) *Background?* Is it simple or distracting, and why? Is there anything in the foreground to get rid of or include? Should I move slightly? How about on either side? Do I need a head-to-toe view? Am I too far back or too close? Have I missed anything? No? O.K. Hold the camera steady. Deep breath. Click!

And the whole process doesn't take more than a second or two. It's all there in the viewfinder.

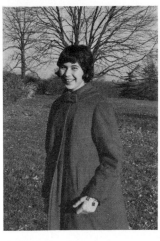

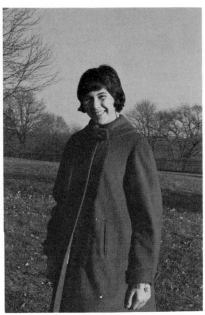

Judy looks like she's sprouted antlers here. That's the way the camera sees her.

Studying the viewfinder, then moving to one side, gets rid of antlers and makes her a pretty girl again.

The Long View

Your eyes can fool you another way. Remember that they're attached to a head that swivels and they see continuously in an ever-changing field. The camera doesn't. So, suppose that like George you lug your camera to a mountain top one day. Your eyes fill with a breathtaking view—a long valley checkered with farms, crisscrossed with roads, dotted with houses, trees, and cows. In the distance a mountain chain stretches to the horizon. And a beautiful river makes a meandering "S" curve across the valley's floor. Smoke curls lazily from a farmhouse chimney, and a tiny shift in the breeze brings the odor of a brisk wood fire to your nostrils. You take a deep breath. What a picture! Your hands tremble as you point the camera, aim and fire. Here's one the family will treasure.

WHAT HAPPENED? Back home you send the film off to be developed, and when your valley picture comes back, what do you have? The farms look like small blotches on the print, the cows like dust specks, and the beautiful river like a baby's scribble. Your breathtaking mountain scene has dissolved to nothing when translated to film.

How come? Your eyes, of course. They saw a wide-screen, technicolor view stretching for miles in all directions. But the camera's field of vision is pretty limited. It doesn't swivel the way your head does, and it can't take in everything at a glance. Not only is the thrill gone, but the odor of the wood fire too. Your eyes, used to looking into the distance, can still imagine cows, roads, and houses life-size. But the camera reduces a 4- or 5-mile view to a couple of inches. Any wonder there's not much left to see? Of course if you really *saw* this picture in your viewfinder, probably you wouldn't have snapped it without making a few changes. But you didn't, so another "great shot" fades into the sunset. . . .

In Chapter 14 are some tips for bringing panoramic scenery to life and giving it depth and interest. For the moment get this rule down pat:

You can only "see" a picture in your camera's viewfinder.

Vertical Viewing

Most reflex cameras have a square viewfinder, but all 35mm and many box cameras have an oblong one. Strangely enough, few people with oblong finders ever bother to turn their cameras on end. Yet fully half of the pictures you see in magazines are *vertical* pictures, and for good reason. Many pictures look better that way.

Here's one of George's more wasteful habits. He poses Uncle Lee in front of the house. Uncle Lee, like practically all people standing up straight, is vertical. But George, backing way off to get a head-to-toe view, holds his camera horizontally or parallel to the ground. Why? Well that's the way you hold a camera, isn't it? Not necessarily. Look what hap-

Uncle Lee occupies very little
of this horizontal picture.

He looks much better when
photographed with the cam-
era held vertically and up
close.

pens if you do. Uncle Lee, in the first picture, takes up *less than a third* of the final print. The rest of the picture includes trees, bushes, poles, part of the alley, and other things George doesn't care about.

To take a picture of Lee alone, all George had to do was turn his camera on end and move closer. Look at the second picture. Lee, standing vertically and snapped with a camera held the same way, fills up the whole picture frame. Now you can see the congenial expression on Lee's face, and the extraneous junk on both sides of him is gone.

You'll discover that statues, buildings, standing people monuments and such usually photograph better up-and-down. You'd be surprised what a difference this makes. Check it for yourself by looking *both* ways before you snap. You'll find lots of pictures in a vertical viewfinder that your eyes didn't tell you were there. George could do it; he just never thought of it.

10. "But It Doesn't Look Like Me!"

George Jr. says his girlfriend Prudence is "the most." She has long, dark hair, bright blue eyes, and a figure which, to avoid criticism, I'd better not describe. Dressed in a bathing suit down at the beach, Prudence would be worth a dozen of anybody's pictures. Last summer Junior had what he called "a ball" posing Prudence in the beach amid stares from envious lifeguards and boys with ugly girlfriends.

Junior's teen-age bubble burst when he tenderly brought Prudence his prints. "George," she said, with a contemptuous toss of her ponytail, "you *know* that doesn't look like me."

"Well," George said, defensively, "you looked that way when I took your picture. Everybody knows the camera doesn't lie."

At least everybody but Prudence. After all, she doesn't care much about pictures themselves. She cares about how *she looks* in a picture, or her girlfriend Bonnie, or that cute new kid Frank. As far as she's concerned, Junior isn't showing her photographs. In her mind she has a vision of a living, breathing re-creation of herself. Her picture is only a flat, black-and-white version of how she looked for 1/50th of a second two weeks ago standing on the beach waiting to be snapped. But she doesn't see it that way. Junior's camera didn't lie, either. It photographed what it saw: Prudence standing stiff as a WAC recruit with a store-dummy's smile on her face. But she doesn't look that way to herself in the mirror smiling prettily from behind her first formal gown. And it's not the way her friends see her most of the time.

How Does She Look? So of course it doesn't look like her— unless she happens to be posing for a snapshot. Then it looks *exactly* like her, because that's the way she *always* looks in snapshots. It's too bad, but Prudence, like practically everybody else, freezes up in front of a camera. Of course this is no sin, but it is one of the strangest phenomena in the world of snapshooting. Most people laugh, talk, run, tell jokes, mow lawns, dance, sip sodas, and think their own thoughts.

Like everybody else, you spend your life doing a thousand vital, important things month after month. This is how people see you and how you like to think of yourself. Yet the moment somebody points a camera at you, you come to attention like a statue. And you don't go back to being a person until *after* the picture ordeal is over.

How often do your pictures really look like you? What story is told by most of the shots you appear in? Probably the same story George Jr. told about Prudence. The same story, in fact, that thousands of snapshooters from Cape Cod to Catalina clutter up their photo albums with year after year:

"This is the way so-and-so looks whenever he's waiting for his picture to be taken."

You call that interesting? Any wonder poor Prudence says, "It doesn't look like me?"

Kids and Candids

One way to get around stiff poses is to teach yourself candid photography. By definition a candid shot is one of people behaving the way they usually do because they don't know they're being photographed. Don't get the idea, however, that candid pictures must always be flattering because they're "natural." People don't always look their best in unguarded moments (halfway through a sneeze, for example). But candids often make good story-tellers.

Kids usually get so wrapped up in what they're doing that you can easily take candid shots like this one.

The best way I know to learn candid photography is by taking pictures of small children. Usually kids aren't very self-conscious and they don't become that way until the adults around them have finally taught them that you have to worry about "looking your best" and "what people think," which is too bad for kids and society as well as photographers.

Did you ever watch a child fondle a kitten or draw pictures in the sand? Have you ever seen a gang of kids playing hop-scotch or cowboys? They're so involved in what they're doing they don't care how they look. Least of all will they give your camera more than a curious glance when there are so many really interesting things to do. A kid would much rather play rocket-to-the-moon than pose for his picture. This makes him an ideal subject for you; and, if you're wise, you won't stop him from playing rocket while you take a snapshot. You'll let him go right ahead while you get a candid picture.

BUT TELL A STORY. Remember, though, that a good candid picture ought to be a story-teller. You need patience to wait for the exact, unguarded, interesting moment. But patience has its rewards. A cute kid with a dirt-streaked face digs earnestly with his toy shovel. But he's turned half away from you and you can't see his face or what he's doing. A picture? Not yet. Hold your fire. Now he starts to get up. Not much interest here. Still no picture. He's back on his knees again, and now he's looking your way and waving the shovel. That's the picture you've been waiting for. Snap it, then wait again. When he starts digging furiously once more move around to where you can see what he's doing. In a moment you'll have another picture as good as or better than the first one. You're working with seconds broken into 50ths, so the trick is to recognize the *right* 50th. It's that priceless instant of action or discovery or elation or anger that brightens every child's life.

Getting at Grownups

It's a nice thing to be able to take cute pictures of cute kids, but don't get swept out to sea on a wave of egotism if you find that you can. Most kids are naturally cute (to adult eyes) and there's not much you can do with your camera to make them act any way but themselves. You don't get a gold star in this course until you can do the same thing with teenagers and grownups. The older people get—at least until they become too old and wise to care—the more self-conscious they

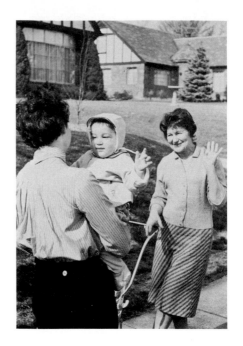

If you catch grownups unaware, you can often snap them behaving like people instead of wooden dummies. Grandma isn't aware of the camera at all.

are. If you doubt this, take another look at snapshots of the older members of your family. Look again at the album next door. It's a pretty rare shutterbug who goes around trying to photograph people the way they usually look when they're not posing. In fact, it's a rare bird who even knows he can.

To take revealing, interesting candids of grownups, you sometimes need a mixture of saintly patience and Indian-scout stealth. But with practice you can learn these in much the same way the saints and Indians did. I'm not speaking now of the kinds of embarrassing pictures Joe the Joker likes to take. You know the ones: Mom with her mouth full of food; Sis with her tongue out; Pop biting his fingernails. Pictures like these are good for a laugh now and then. But most people will forget them pretty quickly if they can. They won't forget the photographer, though, so you ought to be sparing about snapping ludicrous pix.

GOOD CANDIDS. The candid pictures you ought to try for show people behaving naturally, spontaneously, and usually at their best. I mean the warm, honest smile as opposed to a phony, watch-the-birdie grin. Or the relaxed gesture of the hands against a stiff at-attention pose. Or the natural swing of the legs rather than the "hold it" walk where a person stops in mid-action. Or the quiet, thoughtful look of a person not conscious of the camera in place of the tense expression on the face of somebody trying to "look good."

Of course I don't think anybody wants to look *bad* in his pictures. But the harder most people try to appear handsome, beautiful, personable, talented, wholesome, rugged, or intelligent, the more likely they are to look ugly, dull, drab, stiff, sallow, and stupid. It's not their fault, exactly. That's the way they've learned to behave in front of cameras. In fact, it's the "natural" way—for a person with a camera pointed at him. And I'm sure neither you nor I nor Mrs. George does much better most of the time.

But, unlike TV and movie stars, we don't live much of our lives in front of cameras. We deserve to be photographed like the people we are, not the people we fail miserably at trying to be. Your own *real* smile must be a thousand times more winning than a two-bit imitation of Marilyn Monroe's or Rock Hudson's.

WHY DO PEOPLE FREEZE? I think part of the reason we tend to freeze in front of a camera can be traced to photography's past. Picture-taking has been associated with "posing" for a long time. Everybody "poses" pictures. "Hold that pose," you tell a friend. "I like this pose best," she says later, looking at your prints (lucky you if she does). Even the press photographer says, "Hold it while I get a shot."

In effect, then, most of us go around telling people to *stop* what they're doing while we take their pictures: don't move; don't breathe; don't talk; if you have to do something, say "cheese" because it will put a smile on your face. (Take a look at a picture of yourself sometime where the photographer asked you to say cheese. Look like you? Sure it does. That's the way you look when you say "cheese.")

I imagine the "hold it" approach is left over from the old tintype days. Fifty years ago anybody who could make a picture come out without blurring it was practically a magician. He couldn't take pictures at 1/50 sec. the way you do with your box camera. He needed lots and lots of seconds, and because he wanted sharp pictures, he made everybody hold it. If he could get a reasonable likeness onto film, he'd done his duty. What more could you want?

Today we know you can do lots more. We have good cameras and fast films and everybody takes pictures that come out. What's more, we've learned how to tell stories, sketch character, and capture action with our cameras. Why should we settle for modern, stiff-necked tintypes? Even studio portrait photographers want more than just a likeness. Probably one of the world's most famous camera portraits is the "bulldog" photograph of Sir Winston Churchill by Yousuf Karsh. Sir Winston sat for the portrait smoking, as usual, the cigar which is his trademark. But the cigar doesn't appear in this picture. Karsh, dissatisfied with the Prime Minister's expression, stepped from behind his camera and snatched it away without warning. Then he clicked the chutter. You can bet Sir Winston forgot about the camera the instant he lost that precious cigar. The look of anger, determination, and defiance on his face wasn't something you could pose no matter how hard you try. Yet it was the photographer's "skill," not with camera and film, but with people, which produced that look.

Perhaps Karsh's method seems a bit strong to you; but making people behave naturally is not their job but yours. Everybody wants to pose for pictures. It's up to you not to encourage this, but to prevent it. How well you make out invariably shows up in your snapshots. How much of a story you manage to tell in a picture often says as much about you as it does about your subjects. If you snap a person looking stiff and posed and not himself at all, probably you haven't tried to make him act naturally. Or else you didn't know it could be done. Now you know. If the people in your pictures look

natural, busy, active, relaxed, and so on, evidently you were *trying* to photograph them that way.

Natural-Looking Pix

This is the how-to-do-it section. If you're wondering now *what* to do with husbands, wives, relatives, friends, and even strangers who insist on freezing in their tracks every time you heave into view with a camera, here are a few methods that work pretty well for me:

1. Say something to them. Crack a joke or ask a question. If you don't know any jokes ask somebody else to crack one. Ask a woman where she bought her new dress. Ask a man to tell you what kind of fishing rod he's holding or whether he's read any good books lately.

It doesn't matter what you say so long as you get your subjects' minds off your camera and onto *their* thoughts. This is where many photographers go off the track. They think that if a person doesn't *look at* the camera, their picture is less posed. But no matter *where* somebody looks, you can tell when he's got camera on the brain. It shows all over his face. So, if you want natural expressions, change the subject.

2. Often your subjects already are doing something—playing cards, hoeing the garden, jumping rope, or just talking. Don't bother them. Find a good spot, wait for good action, and snap away. If they insist on posing, say something like, "Don't mind me. Just keep doing what you're doing." Or, "If you pose I won't shoot." Or, "I'll let you know when I'm ready." (By the time you're "ready" you'll have taken the picture.) Before long people will forget about you because they have gone back to what interests them. Then take their pictures.

3. Lower your camera for a second if somebody tenses up. People often relax the moment the "threat" of a picture disappears. When a person's guard is down and he's behaving like himself again, quickly raise the camera and snap. Sometimes a crack like "What's everybody so stiff about?" or "This

In the left-hand picture Henry and Lily, waiting for the camera to snap, pose and smile self-consciously. At the right, laughing at a joke and with minds off the camera, they laugh spontaneously. Which shot "looks like" them, do you think?

4. If a picture seems to call for "posing," find something for the people in it to do. But I mean *really* do, not fake. For instance, look at the picture of the group of people sitting on a couch looking in all directions. The picture has no action, no story, no center-of-interest. Compare this with the second version. Quite a difference, isn't there? All the photographer did was tell the people to play with the baby. "Make him smile." With minds shifted from camera to baby, everybody now looks much more like himself. The picture has one idea, a center-of-interest, a cute story to tell. A couple of words from the photographer made all the difference.

5. With strangers try one of two methods. Either pretend the person whose picture you want doesn't even exist and snap him on the sly, or else tell him you would like his picture but would prefer he didn't pose or in fact do anything he wasn't already doing.

Suppose you want a picture of a man fishing off a bridge. Does he insist on looking up and spoiling the shot? O.K. Don't

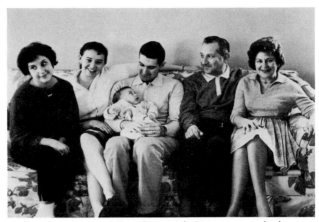

With nothing to do but pose, everybody poses.

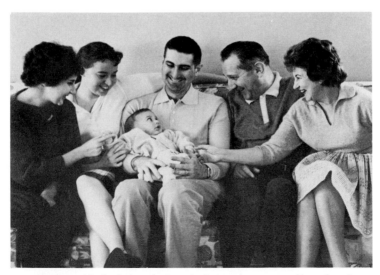

Playing with the baby, the people forget the camera. Now the picture tells a story. Photos by Henry Altschuler.

take it. Ignore him and look in the distance at the sailboats. Pretend you're taking pictures of them. As soon as the man's satisfied you're after boats and not people, he'll go back to fishing. Then grab his picture.

If you're worried about the man's reactions when he hears your shutter click, don't even look at him after you snap. Pretend you took some other picture to one side of or behind him. Don't look at him and he'll never know. This procedure works best with people some distance away when speaking might be awkward.

But don't be shy about asking permission to take a stranger's picture if you really want it. Most people, I've found, co-operate in a friendly way if you tell them what you want. Don't ask me why, but I've more often run across strangers eager to have their pictures taken knowing full well they'll never see them than I have camera-shy ones.

"If you don't mind, I'd like to get a shot of you with the bay in the background," usually brings an answer like, "O.K. with me." Even people who say, "Oh, I'll break your camera," won't protest much if you insist that it will be your camera's pleasure as well as yours. Someone who honestly doesn't want his picture taken for one reason or another usually will make it plain. Respect the wishes of genuinely camera-shy people. Probably you'll find plenty of other pictures and willing subjects in the same place.

6. For the last word in sneakiness—and this works well with friends too—you can always aim your camera in some other direction first. Then watch your intended subject from the corner of your eye. When you see the action or expression you want, whirl around and fire. This is a fairly extreme measure and it makes careful composition tougher. But some-times rapid candid shooting will get you expressions of joy, anger, surprise, or excitement that you'd never photograph at all some other way. Try this method on a wife or girlfriend who insists on posing no matter what. It works.

Now you're on your own. George has never known that interesting, story-telling pictures contain people doing some-thing the way they *usually* do it, even if it's just looking into

space. When people complain they don't "look like" themselves in a picture, they probably mean they look stiff, posed, and self-conscious. Most likely this is true. Your job is to decide what your wife or girl or husband or boy or uncle or aunt or sister or brother really *does* look like. What's his or her best smile? Does he usually look thoughtful? Does she wrinkle her nose a certain endearing way? Go after characteristic expressions, not stiff poses.

And don't be surprised when your girl gives you a big hug and says shyly, "Gee, I like that one of me the best." Just relax and enjoy it.

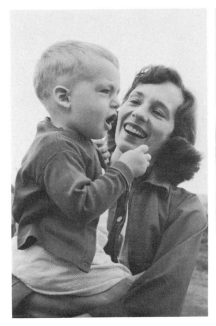

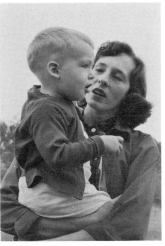

When you're working with seconds broken into 1/50ths, each instant brings a new picture. Above Jean and Rickie show little expression. Jean's smile and Rickie's shout make all the difference at the left. Which do you like?

11. Keep Your Snapshots Simple

If George's snapshots suddenly blossomed with animation and story-telling action, he'd have a right to pat his own back. But he wouldn't be an expert snapshooter. Not yet. He'd still have to learn to put only one idea into each picture and to arrange the people and objects in his pix so that they're pleasing to the eye.

Roughly, all this comes under the head of *composition*. To George this is a dirty word. "Sounds like something we used to write in English class," he once grumbled to Mrs. G. after reading a camera instruction book. What he didn't think of, though, was that snapshooters use lines, shapes, and angles rather than words, sentences, and paragraphs. And they don't even have to think them up. The elements of good picture composition are there for the taking: trees, sidewalks, poles, steps, mountains, autos, people, and the shadows cast by same.

Picture composition shouldn't strain anybody's creative powers. You compose a picture *every* time you point your camera. That is, you arrange things *some* way between the top and bottom and sides of the viewfinder. The difference between good and bad composition depends on (a) what you arrange and (b) how you arrange it. For whatever you see in the viewfinder becomes part of your composition—excellent, good, fair, or poor.

If trees are flying in all directions, if an empty swatch of street takes up half the picture, if somebody's just about to walk out of sight, and if the whole world is tilted, then you flunk. But if your subject fills the picture frame, the background blends nicely, the picture's idea is clear, and nothing shows up to disturb the viewer, you may pass with a high grade.

Most pictures fall between these extremes. George's, sad to tell, usually aren't much good. He doesn't pay attention to what's behind or in front of people in his pictures. He doesn't care where his subject happens to be in relation to everything

else. He grows trees out of heads as casually as some people grow petunias. He turns what should be pictures of his wife and kids into pictures of grass and sky, not by magic but simply by carelessness. But he doesn't have to.

Where's the center-of-interest here? There isn't any because George had no clear idea of what he was doing.

Three Simple Rules

Keeping your snapshots out of the George class depends on how well you can do three fairly easy things:

1. Stick to one idea for each shot. That's what we'll talk about in this chapter.

2. Position yourself and your camera in such a way that what you snap clearly shows your idea. We discuss this in detail in Chapter 12.

3. Arrange whatever appears in each picture so that the subject and its background harmonize rather than clash. Chapter 13 deals with this.

To make good picture compositions you don't have to be an artist or a genius. You don't even have to have good grades in English. You just have to learn to see and believe your eyes.

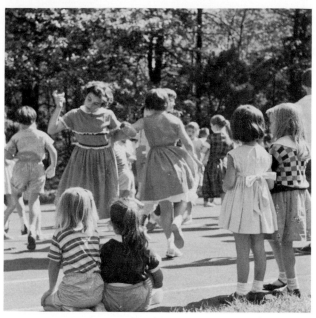

Here you can clearly see what this is a picture of. It has a clear center-of-interest. It tells a story.

How to Stick to One Idea

Even in his "line-up-everybody" shots George sticks to one idea much of the time. It may not be a very good one, but it's there. But when he starts snapping "over-all" pictures of scenery or a beach full of people, he usually loses his head (and his subject). Notice George's playground shot. His daughter is in that gang somewhere, but you'd never be able to pick her out. Sure, George saw her when he snapped. That's the whole trouble. His idea was to get a picture of the whole playground, including little Georgette. So he pointed his camera at the works, rather than his daughter in particular. What story does this picture tell? Where is the picture's subject? Now that he's seen it, George couldn't tell you either. He realizes that when he took it he really had not clear idea of what he was trying to do.

This has nothing to do with how far away he stood or the number of people in his picture. George might have stood anywhere at all, included as many or more children, and still made a better playground picture. All he would have needed was a single, clear-cut *idea* of what his picture should be. Then he might have lined up the kids according to his idea, some in the foreground, some behind, his little daughter and her partner right at a "center-of-interest." Can you doubt for a minute what the idea of the second picture is? George

This picture has a clear center-of-interest, the two men walking down the road. Without them it wouldn't even be a picture.

could have taken it just as easily as the other, if he'd invested 25 or 30 seconds checking his viewfinder. Of course he'd have had to know what to look for, and for the most part he doesn't.

Don't let George's ignorance stop *you*. Before you snap an over-all scene where there's a lot going on, ask yourself, "What am I taking a picture of?" If your answer is "the beach" or "a street" or "the playground," you might as well write the

picture off in advance unless you're just naturally lucky. In a beach scene, better put that little girl playing quoits in the foreground to one side and build your picture around her. Or else concentrate on that couple listening to the portable radio. You can get the rest of the beach in too—splashing kids, lifeguards, girls strolling up and down, people eating popsicles—but stick to a single, clear idea to tie everything else together.

Here's the secret of simple snapshots: *Stick to one idea, but make sure you have one.*

CENTER-OF-INTEREST. If you look at the playground pix again, one thing ought to strike you instantly. In the first picture your eye doesn't go to any special place. It kind of fishes around, lighting here and there, looking for a spot that makes sense, a person or a thing that gives it some clue as to what the picture is all about. But your eye never finds that spot. It doesn't exist. In the second picture, the people you see right away are the two dancers nearest the camera. They make the picture's *center-of-interest*. They tell you what the picture is all about. The two pairs of little girls watching the dancers help the picture's visual appeal. They help direct your eye to the dancers; they make a little pattern too.

But the real center-of-interest stands out clearly. It's the point where your picture's single idea is carried out. It's the spot around which the rest of the picture revolves. Without a center-of-interest you don't even have a picture, properly speaking. This center-of-interest can be anything: two people talking or walking; a child playing; a church steeple; a willow tree. Nobody should have to look at your shots and say, "Well, it's nice . . . but what is it?" If it has a center-of-interest they'll know.

Other Composition Tips

Here are a few more pointers to help you keep your snapshots simple:

Below is a typical George shot with Kim placed smack in the picture's center. It has no life.

With Kim off center and **doing something,** the picture looks better.

1. *Don't "center" things up.* This may sound contrary to what I just said, but it isn't. A person standing or sitting smack in the center of a snapshot usually means a dull, lifeless picture. Much too formal. It's better to find some way to move a subject to one side or the other, then balance him with something in the remainder of your picture frame.

2. *Place your subjects by the "rule of thirds."* This rule says that the natural center-of-interest in a picture frame occurs above or below the centerline and off to one side. Really, this is the easiest thing in the world to follow. Line a picture up in your viewfinder. Then see if you can move the camera just enough to right or left to throw the center-of-interest toward one of the picture's corners. The trick is to pay attention to *everything* you see, so that when you put the subject off center, whatever takes up the rest of the picture will fit with the subject and balance it without yanking your eyes away.

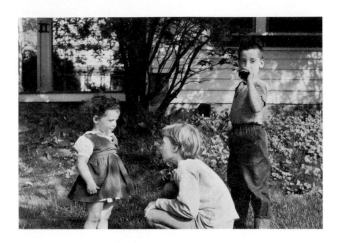

This poorly composed snap-
shot shows the kids more or
less in the center.

This snapshot, composed by
the "rule of thirds," looks
better.

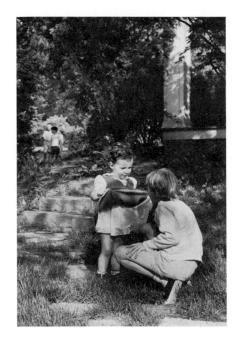

82

3. *Make people look into your pictures and not out.* Often, if a person's gaze shoots dreamily into space from near the edge of your picture, the gaze of the viewer goes right along. Only there's no place to go. It's better to arrange your pix so that people look *into* them. Viewers will do likewise because they will be compelled to by the people in the picture. One of the commonest ways to call attention to scenery or signposts and so on is to have somebody off to one side facing in.

4. *Give people room to move or face.* Don't misunderstand tip number 3. It's perfectly O.K. to have people looking to one side or another in a picture or moving in some direction other than forward or backward. But give them *room*. If a person's looking from left to right, leave lots of picture area on the right. If somebody's running or jumping or hopping from right to left, leave the person someplace to go. Don't compose the picture with one edge blocking your mover's path. It makes viewers uncomfortable.

People should be facing into your pictures, not out of them. See the difference here.

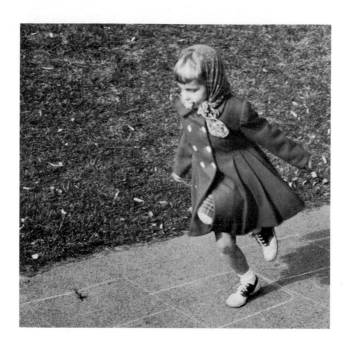

Always leave the people in your snapshots someplace to move into.

5. *Don't divide your center-of-interest.* What this means is try not to have something happening in two distinct and widely separated places in your picture. Your eye won't know where to go first and your picture will fall apart. Even two people talking together can turn into a divided picture if there's a lot of open space between them, or a pole, or something else running through the picture's center. Notice the snapshot of the two little girls at a birthday party.

IT'S YOUR MOVE. Often the simplest way to simplify a picture is simply to *move.* Move yourself and the camera, or move the people in the picture. This is an especially nice thing to do when a background threatens to kill your picture idea and steal away the human interest. Here are a few examples:

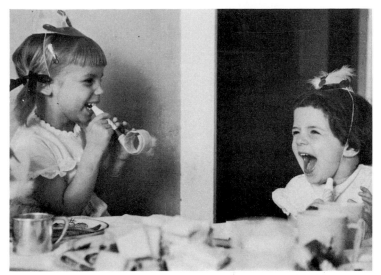

This is really two separate pictures because the doorway divides the
shot in half. Try not to split your pix down the center.

Backgrounds can also be simplified by moving yourself—changing camera angle,
that is,

1. *Move the people.* In the first group picture, among the trees, houses, wheelbarrow, and clothesline there's not much room for the gang. You don't really see them, no matter how hard you look. A few feet farther north, on the lawn, you get a simple snapshot with the emphasis where it belongs—on the people.

2. *Move yourself.* You don't have to accept an automobile, garbage can, and stone wall in what ought to be a picture of three cute kids on the swings. Moving a little way to the left you simplify the picture and put the subject interest on the children instead of sharing it with the car. Result? Much better picture.

The moral to this chapter is that you ought to try to tell *something* in every picture. But don't use things in your pictures that don't add to your story. A photographer friend of mine says he thinks of composing a picture the way you might think of furnishing a room. You want to pick pieces that go well together. You want balance, harmony, and a nice arrangement of chairs, tables, paintings, drapes, cabinets, and so on. You want to avoid clutter and strive for simplicity.

I think this is a pretty good tip for George. I'm sure his snapshots don't reflect badly on his wife's taste in furnishing. But if they did I'd hate to see his living room.

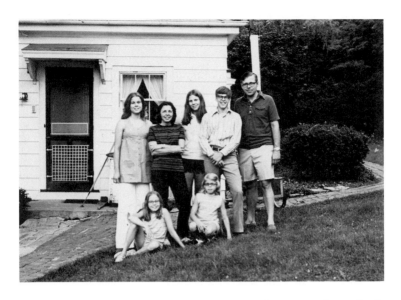

One way to improve a picture is to move your subjects to a better locale. Second shot was taken on the lawn at the right in first picture. Photos by David Willis.

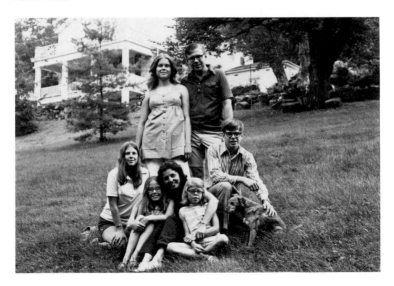

12. What's Your Angle?

You've probably noticed that George takes all of his pictures standing up straight from 10 or 15 ft away. It doesn't matter whether he's snapping infants, buildings, scenery, or his wife. He points his camera down for kids, up for buildings, and straight ahead for grownups. What's more, he never moves around to the side of anything. George's friends and family have no profiles, just full faces. His buildings have only one wall, the front one, and they usually lean over backward. It's a wonder they don't collapse. His little kids always look smaller than they really are for the same reason that the Empire State Building looks small in an aerial photo.

Oh, sure, George has seen those crazy news photographers climb ladders and creep on the ground. "Boy, those guys do anything to show off what big deals they are," he tells Mrs. G. He can't imagine that the news photographer knows his

business: he wants an unusual *angle* on his picture, a point of view that turns an everyday shot into one people will look at and talk about.

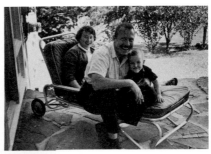

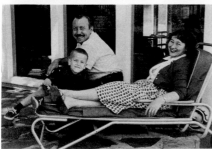

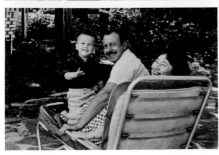

Here are four snapshots of Ingrid, Paul, and Doug. Each picture shows them sitting in a lounge chair back of their house. But notice how different the pictures are from one another. Each angle gives a new background, a new selection of shapes, new patterns and textures. Each click of the shutter brings new facial expressions. Why settle for a typical George-type front view when there are so many pictures possible in one spot?

Get on your subject's good side. Notice the distorted leg in the head-on version. See how much better Mimi looks from one side.

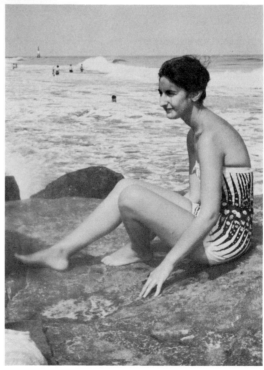

The pros know that every time they change camera angle, even slightly, they change their pictures, sometimes from ordinary good shots into great ones. Photography has lots of angles, and you don't have to become an ant or a steeplejack to learn them. But learn them you should if you want people to tell your pictures from those of the guy next door or those horrible shots your brother-in-law takes.

Learning the Angles

Start teaching yourself the angles today with this experiment: pose a friend out-of-doors. Line him up in your viewfinder in such a way that a tree or pole grows out of his head. If you want to be really fancy, use a streetlamp or a traffic light. Notice how easily you can do it. Now move a step or two to one side or the other, and watch what happens to the tree or pole. Now notice what happens to buildings, sidewalks, fences, and everything else in your frame each time you swing the camera or step aside. Can you see your friend *against* the background and imagine how he'll look in a flat picture? Could you find an angle from one side of your friend or another where his head wouldn't conflict with the background? Try it. If things keep getting in the way, stoop down for a second, just low enough to throw your friend's head against clear sky between two trees or buildings or against a fairly simple wall. Can you imagine how many thousands of backgrounds are available in that one spot? Why photograph confusion, then, or grow a tree out of somebody's head?

ON THE GOOD SIDE. Obviously the easiest way to change a picture's background is to move camera or subject to one side or another. While backgrounds are important, and while the camera is not like your eye, you still don't want to lose sight of the subject altogether. When you pick an angle, from one side or the other, make sure it's good for the subject as well as background. For instance, head-on shots of people sitting down usually turn out losers. Arms and legs closest to the camera seem to have grown all out of proportion, bodies be-

come elongated, and other strange things happen in these pictures. You're better off picking an angle to one side or another on people sitting down.

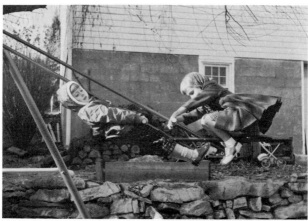

These two pictures of the kids on the teeter-swing show both the high and the low of angle shooting.

Hunt High and Low. Unless he happens to be aiming up at a building or down into a canyon, George never points his camera up or down on purpose. His theory is that you can take every picture from wherever you happen to be standing. And he's right. You can. And they'll all look just that much more alike.

There are two exercises any snapshooter can practice which are guaranteed to eliminate sameness-of-angle from his pictures. One is climbing. The other is bending at the knees.

The object of each exercise: to bring a fresh, interesting, alive-looking viewpoint to the same old tired pictures. Shooting from up high or down low often will give you exciting pictures you didn't realize were there. Take the two girls on the teeter-swing. But don't take them head-on in the usual way. First, climb up on a crossbar and shoot down (after getting your subject to look up). Notice what a nice background the grass makes. Then, for drama, get down low and shoot up at the girls while they swing. Same subjects. Far different pictures.

Whether you shoot high or low, and when, depends pretty much on your own inclinations. I can't say use high angles for this, this and that, and low angles for these, them and those. If your knees aren't too stiff, you should be able to find out which angles work where. Don't think you have to be a mountain lion either. Sometimes you can get an interesting high-angle picture simply by climbing halfway up a flight of stairs, standing on a park bench, or aiming out of a second-story window. The point I'm making here is that there's no law against this kind of snapshooting, although the way George and his friends avoid it you'd think there was.

The Lowdown on Kids. Low angles work especially well in pictures of children. Photographer Wayne Miller, who took 30,000 pictures of his own four kids for his book, "The World Is Young," discovered this fact very early. After that, Miller says, he took every picture from the *child's* own viewpoint so that grownups might see the child's world the way other children see it.

Notice how much better the kid's-eye view in the second picture of Kim and Bill looks. George usually takes the first one—standing above the kids.

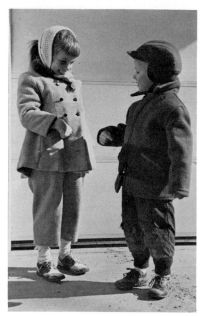

And sitting people, simply because they're sitting, need not always be photographed from above every time, either. Notice the intimacy and warmth of the picture of Kit and her baby taken from an angle more compatible with the way the subjects are. Again, it takes just a little bending—and a fresh point of view.

Buildings, Statues, Monuments

George visited The Pennsylvania State University last spring and took what he calls a "sensational" shot of Old Main building. Only he just can't figure out why the building seems to lean back. "Maybe that's the way they built it," he tells Mrs. George. Come to think of it, houses have a way of leaning

People sitting often make more interesting subjects than the same people standing stiff at attention, especially when snapped from a low angle.

back in his pictures, too. Maybe the whole world's crazy. Oh, well, George shrugs, They'll probably perfect those cameras one of these days.

It would never occur to George that what needs perfecting is his own way of pointing a camera. Leaning tower pictures happen for only one reason: you aim your camera *up* at an angle to photograph something high. Old Main soars off into space in 3-D, but the camera must translate width, height, and depth into 2-D—a *flat* picture.

To make a straight-up-and-down building look that way on film, you have to hold your camera straight-up-and-down. It's as simple as that. Often you can use the distorted leaning effect to dramatize a picture. But when the building just leans for no apparent reason, like George's shot of Old Main, it doesn't make sense. In that shot George aimed his camera up instead of straight ahead. It's a natural tendency to want to get a tall building in all the way to the top of its tower. But if you tilt the camera, the building leans.

Sometimes deliberate distortion gives you a dramatic shot of a building like this one of Penn State's Old Main.

In this George version not only is there no center of interest, but also the building seems to lean back.

By moving back far enough you can hold your camera straight-up-and-down and make buildings look the way their builders built them. Note student in foreground as center-of-interest.

Houses snapped from one side only look like painted scenery. See how much more realistic the house looks pictured from an angle to show two elevations.

STRAIGHTENING THOSE BUILDINGS. There are two easy ways to get around a leaning tower.

1. *Get up higher yourself.* If you shoot from the second floor of a building across the way, it's pretty easy to hold your camera straight (perpendicular to the ground, that is). This may be unhandy, of course. But if you have a bench, a stairway, or a stone wall in the vicinity, you can climb up and put yourself nearer the building's center. This will help you get rid of some of the camera tilt.

2. You can always *move back* until you see the whole building straight-up-and-down without tilting. This idea has its drawbacks. For one thing, you get more foreground. For another, your building appears smaller the farther away you move. You can put extra distance to work for you, though, by filling up that foreground. Is there a garden in front of your house? Is there a tree some distance from the building which you can use for a frame? Better still, are there some people handy to give you a point of interest in your picture's foreground?

GIVE BUILDINGS TWO SIDES. The front view of a house is another George special—the one-sided house. He'd never think of living in what looks like a piece of Hollywood stage scenery. But he thinks nothing of standing out front and photographing it that way.

The remedy for this illness is painless. Simpy change camera angle toward one corner of the house or another. Include *two* sides by shooting at an angle to the front, Now you get depth, some perspective, and an illusion of reality. Which house would *you* rather live in?

13. Make Your Snapshots Look Good

My friend George gets so wrapped up in his subjects—wife, kids, friends—that he pays little attention to how his pictures *look*. If George can get Aunt Susy in the picture, he doesn't much care what else gets in. As we've seen, there's no sleight-of-hand needed to take a good picture of Aunt Susy. You get the old girl to smile, move in close so her face will show, and fire away. You watch the viewfinder image. You get rid of telephone poles, clotheslines, and ashcans in the background by changing camera angle or by moving Aunt Susy.

Anybody who's now able to take his best girl's picture without including a mailbox, stop sign, and two parking meters deserves some praise. But it's time to take one more step away from the George-type picture. If you can make your pictures simple and interesting, you can also make them good-to-look-at. It's not George's fault that his pictures aren't exactly works of art. He's never thought of them as anything but snapshots—likenesses of people he knows. Though people often complain about how *they* look in his snapshots, they rarely comment on how the *pictures* look. I suppose this is because, like George, most people don't care much about pictures. But, curiously enough, in a good-looking picture the people often look better too.

Picture Patterns

Luckily, the picture elements which add beauty to snapshots surround you all the time. You walk through, around, toward, and into nice picture settings all day long. Probably you don't recognize them. Have you ever noticed, for instance, the *pattern* a row of trees makes along a sidewalk? Or a row of houses? Or a row of fence posts or telegraph poles down a highway? Look down the street the next time you're out. Have you ever noticed the shadow pattern cast by the sun shining through a picket fence onto the sidewalk? How about

Notice how the windows and the lights and shadows make a pleasing, regular pattern. By itself it's not much of a picture. But it **is** a good picture background. See what happens when the bike rider becomes the center-of-interest.

the pattern of rectangles and lines made by the windows and columns of the courthouse or library or post office? Such patterns are the "stuff" of good picture backgrounds.

If you use your eyes you'll discover pattern backgrounds everywhere to help improve your pictures. See how nicely the building complements this shot of Mimi. Photo by Lennart Anderson.

Picking a Pattern. Choosing a pattern to use in a snapshot is something like selecting wallpaper, drapes, rugs or windowblinds. From a variety of samples you choose items which please your eye and fit nicely with your furniture. Furnishing a snapshot requires much the same selection. You need objects, shapes, lines, and patterns which fit your picture and please your eye. They ought not to call attention to themselves except as they direct attention to the picture's story. Your sample selection depends on where you are. The park, the street, the yard, the dining room, the basement—each offers a different variety of possible patterns. But the patterns are limited only by your patience and imagination.

Using a Pattern. Almost any group of objects similar in size and shape may become a picture pattern. Curiously enough, this applies to *people* too. The bobbing heads of children in a schoolyard make a pattern just as surely as the criss-crossing paths in a park. Even people standing in line at the

Even **people** fall into patterns, as do the children in this group watching a parade. Can you see them as parts of a **design** as well as familiar subjects? Photo by Joseph Nettis.

movies make a pattern, if you forget for a moment that they *are* people and see them instead as parts of a design. Actually, patterns have little to do with subject matter. When you see pictures as patterns, though, your subject matter can be made to look good too.

How do you develop a sense for interesting lines and shapes? Two ways: first, by using your imagination as you observe a scene; second, by consulting your camera's viewfinder as you arrange your picture.

MORE "GOOD-LOOKING" ELEMENTS. Don't let the term "visual element" baffle you. It's a convenient way to name *anything* which helps make your picture attractive. Here is a brief list of other visual elements to watch for:

1. *Textures*—Brick and stone walls, grassy lawns, old wooden doors have textures, just as linen drapes, woolen shirts, and corduroy pants have. Textures often make pleasing foregrounds or backgrounds in the simplest snapshots. Don't cen-

Texture in water and boat bottom help make this shot good to look at.

See how the **shapes** of pots, stove, and cabinets harmonize with Mahala sitting at the table.

←Mimi Anderson photo

Here the horizontal **lines** in fence, bridge, and bench complement the vertical lines of the three men.

As subject matter, the kids are playing ring-around-a-rosy. As design they form a series of **curves.**

Almost any foreground object can make a picture **frame.**

ter Uncle Fred against that old wood fence. Move him to one side and let the fence texture show, too, by balancing him with the fence itself. You get a simple picture, and a good-looking one. Textures, by the way, often stand out best when strong light comes from one side or the other to cast tiny shadows. (See Chapter 15 for more on lighting.)

2. *Shapes*—The way things are shaped in your picture can make or break it, and this goes for benches, lamps, buildings, autos, and what not, as well as curvy females. Sometimes you balance large shapes with smaller ones, circles with squares, triangles with straight lines. A big, round snowman may be interesting subject material for a snapshot, but don't forget that his shape *can* add visual interest too. Don't expect him to look good if he has to compete with straight-line electric wires for attention. Try to see the snowman's roundness in relation to a small child or group of children, and group all of their shapes for a pleasing effect the way you group furniture in your living room.

3. *Lines*—Some subjects naturally seem composed of vertical lines or horizontal lines. Look at a row of people on a park bench. They make a set of short vertical lines against a long horizontal one (the bench). From the proper angle this arrangement can be quite pleasing to look at. Try to plan such a snapshot so that its natural lines fit your photograph. A man leaning against a porch column makes a vertical picture. He's straight-up-and-down; so is the column. Treat this picture as a vertical, and place all the vertical lines in your viewfinder so that they emphasize the man. But be aware of the lines and try to get rid of other visual elements which might conflict with them. You can often see good linear elements in doorways, arches, buildings, signs, etc.

4. *Curves*—You know how a road looks when it curves around a bend. How will the same road look in a photo? Can you place it in your viewfinder so that it seems to curve into your picture? Two people bent toward one another in conversation may form a couple of related curves. Don't spoil their picture by cutting off a part of one person or the other. Use the curves as well as the people to help make your picture look good. Watch for curves in tree branches, roads, paths, people lying on beaches, etc.

5. *Frames*—One sure way to add visual interest to a picture is to frame it. Have you ever taken a picture from inside the house looking out through a doorway or a window? You can

You can make clouds a part of your composition when you use a yellow filter to darken the sky.

use the doorway as an interesting frame for the people outside. Tree branches sometimes make good picture frames. So do fences, arms and legs, signposts, and anything else your imagination will let you see. Frames also give your picture depth (that is, the three-dimensional look).

Using Filters

Filters, especially yellow ones, have become such everyday accessories they deserve a few words here. In my opinion the main reason for using a filter over your lens is to make a picture look good. The garden variety yellow filter has one important use: it will make blue skies look darker.

Simply darkening a washed-out sky isn't worth much in the average picture unless clouds are there. Then a yellow filter darkens the blue sky as usual—and lets those big, billowy, puffy clouds stand out strong and clear. But it's a good idea to give the clouds some attention. They become part of your composition. If you're photographing the family standing on the mountain ridge, place them against the clouds in some nice way. Ditto for church steeples, monuments, and so on. Try to use the clouds to direct attention to your subject.

Remember, too, that if you own an adjustable camera it ought to be opened anywhere from one to two lens stops with a filter over the lens, depending on what color the filter is. There's plenty of filter literature available free from your local camera store. So let's move to more important topics.

14. "Wow, What a Picture!"

You have to say one thing for George. He knows pretty scenery when he sees it. Whether it's a tranquil scene by the lake in the park, a dazzling city skyline, a range of mountains rising from the plains, or a herd of cattle grazing as far as the horizon, it touches something deep down inside of George. "Wow, what a picture," he tells Mrs. G. "Stop the car. I've just gotta have this one."

So Mrs. G. pulls into a gravel parking area at the shoulder of the road. "Pleasant Valley Observation Point," reads a rustic signpost. "Elevation 2416 feet." There's a pair of binoculars on a swivel mount (10¢ a look), but George doesn't want to look. He wants to take pictures. There it is, Pleasant Valley, a deep gash in the mountains filled with reds and greens and browns and a thin line of blue river. George sniffs the October air. It's like Cinerama, he thinks, pointing his camera down at nothing in particular.

George stands about as much chance of putting the grandeur of Pleasant Valley into a double-size snapshot as he does of loading the valley into his station wagon and carrying it home. He's forgotten you can't get it all in. But he'll soon remember—when the film come back from the drugstore, and Pleasant Valley is only a pleasant memory.

The funny thing is that snapshots of scenery follow the same rules as snapshots of anything else. They must be simple; they must be good to look at. But above all, they need a strong center-of-interest. George misses this point completely because he's so carried away by the bigness of the view, the grandeur of the buildings, the majesty of the clouds. But his camera is no more like his eye than it was five chapters ago.

Even with nice scenery your eye needs a *first* place to light, a jumping-off point from which to see the rest of the picture. Have you ever noticed the long scenic views in the travel ads? Invariably there's a nice-looking girl in a red sweater looking out across the bright lake. Notice that the girl is looking at a

Lazy River Day Line excursion boat whose decks are crawling with sight-seers. That boat is your center-of-interest. The green hills on either side, the trees, the houses, the high bluffs—in other words, the scenery those sight-seers are out to see—form a backdrop for the little boat. Sure it's a spectacular scene. But that boat's the center-of-interest because this is an ad for excursions on the river.

In Three Dimensions

Because most scenery happens so far from the camera, you have to pay special attention to perspective in a long shot. It's so easy to shoot a flat, long-distance picture with nothing in it. But you don't have to. In the excursion ad the girl in the foreground serves a purpose. She gives the picture depth, a feeling of three dimensions on two-dimensional film.

The best way to give your scenic views this same feeling is to find some foreground interest—a person, a tree, a building, a boat. It doesn't matter much what as long as it's (a) pertinent to your picture (i.e., it fits) and (b) it's *much closer* to the camera than anything else. The relative size of your foreground objects is the secret of that 3-D feeling. We're accustomed to seeing close objects large and distant objects small. Even though a snapshot reduces grand views to tiny space, the size *relationships* stay the same.

This doesn't mean that somebody in the foreground looking out over the canyon must dwarf even the scenery. Perhaps you want to emphasize how fantastic the view is, how insignificant the people. You can still do it by making the people the center-of-interest in the *relative* foreground of your picture.

One of the neatest devices for making distant people, buildings, or scenery seem to live in a photograph is the tree frame. Just a swatch of leafy branch in the *foreground* of a picture can make whatever's in the background seem to leap forward instead of disappearing.

A WORD OF CAUTION. Tree frames and other foreground interests are fine, but be careful not to place them *too near* your

Try to imagine this picture without the two men in the foreground. Can you see how flat, lifeless, and indefinite it would be? Scenic pictures need a strong center of interest. Photo by Joseph Nettis.

camera. Within 5 or 6 ft they may be out-of-focus and spoil the view. About 20 or 25 ft is plenty close for a fair-size tree branch. If you consult your viewfinder you'll discover it will frame nicely at that distance.

Tip for adjustable camera users: in a long view in order to focus at infinity, all you need to do is set the rangefinder infinity mark (which looks like an "8" on its side) opposite the *f*/number you're shooting at on your depth-of-field scale. Distant objects will stay in focus, but your range or depth or sharpness will move in toward the camera, making it possible to get near objects sharp too.

WATCH YOUR PATTERNS. Often scenery makes interesting patterns if you sharpen your eye enough to spot them. Don't be so carried away by the view that you forget *composition* entirely. The farm scene in the accompanying picture makes a

112

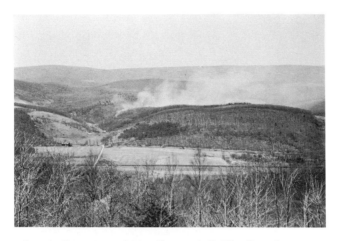

Here is George's pathetic effort to boil 75 miles of scenery down to a few inches. Without a center-of-interest the picture tells no story.

One way to use what's handy and improve the long view is shown here. Can you think of others?

Notice the **visual** arrangement in this quiet scene.

fairly nice-looking picture. Can you see why? There's a pattern of sheep sprinkled on the hillside and a nice arrangement of buildings in the background. You mustn't overlook the *visual* qualities just because a scene temporarily takes your breath away.

Remember, the people who look at your pictures later weren't there with you that day. They didn't see it. And unless you've put a little work into your snapshot they never will—at least not the way you did. How do you know when you've really taken a scenic picture that has everything? Easy. The first time somebody looks at your print and says, "Wow, what a picture!"

15. "But the Sun Isn't Over Your Shoulder . . ."

Here's a myth George has lived with for years:

"Always have the sun coming from over one shoulder." This rule is about as old as the Dodo bird. Too bad it's not just as extinct. George never snaps a picture without looking uneasily over one shoulder to make sure that the sun's there. Result? He misses a lot of good pictures and fouls up many others.

"Looks cloudy today," he tells his wife. "No sense taking the camera to Grandma's." So there'll be no pix at Grandma's today.

Or, down at the beach, Mrs. George yells, "Hey, look at Junior building a sand castle? Why don't you get his picture?" George glances skyward. "Can't," he says. "Sun's behind a cloud." But by the time the clouds have moved on, so has Junior. He's a block away in the water.

Because George thinks he has to make *all* his hay while the sun shines, he's always running into shadow problems. The truth of the matter is that you don't *need* bright sunlight to take good pictures. Medium-speed films work fine in bright shadowless places whether the sun's out or not. In fact, when you're interested mainly in snapping a face, you'll take a better shot of it by moving its owner out of the sun. That way you eliminate ugly facial shadows. On hazy or cloudy bright days you can do the same thing without going anywhere. And even with a box camera you can take good pix in filtered sunlight under a tree or in the wide-open shade by a light-colored wall. Try a simple portrait of somebody you like in soft shadowless light. Save the searchlight effect of high, bright sun for intentional dramatic effect (or for people you hate).

Using Sunshine

Don't get the idea that you shouldn't ever take pictures of people in the sun. Above I was speaking of portraits, closeups of faces. Sunlight can do wonderful things when you use it on

In this midday snapshot of Dotty and Joey the harsh shadows beneath eyes and nose look ugly. This is poor light for snapping people when you're interested in faces.

When the sun's behind a cloud you can make fine pictures of people by the soft, even light—as in this informal portrait of Anita. Medium-speed films are fast enough.

purpose to achieve certain effects. But to use sunlight properly, you have to be conscious of where it's coming from. Contrary to George's rule, sun can strike your subjects from *any* angle, including either side or even from behind. Sun-over-the-shoulder is only *one* possible angle, and often it's the worst one. The time of day you take a picture can also change the sun's effect. The shadows-under-the-eyes shot was made at high noon. A couple of hours later the sun would have moved lower in the sky, erasing the shadows in the same shot.

WHERE SHOULD THE SUN BE? In a snapshot the sun ought to come from whatever direction you think will help you make a nice-looking picture. How a picture looks depends partly on how it's lighted. Light coming from one side creates a much different mood or feeling than light coming from behind one shoulder. And light coming from *behind* your subject instead of from behind you creates a different mood still. Let me try to give you some idea of what each lighting angle does.

SIDELIGHTING. Light hitting your subject at an angle from one side or the other emphasizes shapes, patterns, and textures. It sets up all kinds of little shadows, spills into the background behind people, and gives depth and roundness to faces. This effect is called "modeling," something you positively don't get when the sun is coming from behind you.

You can sidelight a picture simply by placing yourself at a 90° angle to the sun. But if that's unhandy you can always ask a person to "turn a little more to the left" or do whatever is necessary to get the sun at his side.

Sidelight often makes the best picture of the old homestead, too. It sets up shadow patterns around the windows, porch, bricks, columns, stones, clapboards, and so on. With the sun hitting the house head on, you don't get much play of light and shadow. But when the sun moves off to one side (and you do the same to take advantage of an angle that gives you two sides), you'll get good visual interest and depth.

BACKLIGHTING. George has *never* taken a backlighted picture. He knows you should never point a camera toward the sun. After all, how can your subject be well lighted if the sun is behind instead of in front of it? It can, of course. It all de-

Here are two examples of sidelighting. Notice the "modeled" effect on the faces. They have shape and roundness; the figures seem separated from their backgrounds. Top photo by David Willis.

pends on what you mean by "well lighted."

Frontlighting literally floods a picture with bright light and makes it clear and sharp. Backlighting gives you drama, depth, mood. It can make a picture "feel" dark and eerie. Or stark and lonely. Or soft and quiet. Or a thousand other ways, depending on what you see, how you feel about it, and how you use the light.

To take backlighted pictures, the only thing you must remember is never to let the sun strike your lens. It doesn't matter which direction you point your camera as long as you keep the sun from shining through the aperture. George has some fuzzy notion that just because his subject should be in the sun for a picture, he has to be too. This is nonsense. The *camera* can be anywhere—up a tree, down a well, in the barn, or on the living-room side of the picture window looking into the yard. As long as what you point the camera at is in the light, you'll get a picture. Once again it doesn't matter where the light is, either, as long as it doesn't hit the camera opening.

Backlighting brings out the texture of the grass in this picture and gives an interesting semi-silhouette effect.

So to take backlighted shots stand under a tree or inside a doorway. Shield the camera behind a post. In an open field let a friend hold his hand between the direct sun and your lens to throw a shadow across it. (But make sure his hand doesn't get between camera and picture). Or use a lens shade.

Backlighted pictures of people out-of-doors usually lack detail in faces and other shadow areas. That's O.K. You want a mood, not a passport picture. Notice the way backlight creates a halo effect around your girl's head and shoulders. Notice the way it throws long shadows toward the camera (good visual interest, of course). Scenery often shows up best backlighted. Country roads, beach shots, town square, even backyard picnic all take on a special quality snapped late in the day with the sun behind them. So do lake and sea scenes with the sun bouncing off the water.

SILHOUETTES. A special kind of backlighted picture is the simple silhouette. Even with a box camera you can snap silhouette pictures indoors by standing somebody near a window so that the bright light is directly behind him. Use a plant on the windowsill or lacy curtains to make a silhouette picture look good. Sunlight streaming through a window provided backlight for the picture of Kim on the cover of this book.

So the sun isn't over your shoulder. Why should it be?

16. Where's the Action?

George never takes action pictures. He simply waves his camera around and yells "Hold it!" and everybody does. So his album is filled with pictures of the kids standing beside sleds, bikes, and horses or clutching baseball bats, basketballs, and volleyballs in their stiff little fingers while they stare at the lens.

"The book says you can't shoot moving people with a simple camera," George would say if you pinned him down. Funny how he remembers bits and snatches of the book when he's trying to excuse his own ignorance. Probably if he went back and read it again he'd discover that what it *really* says is that you *can* take action pictures if you follow a few simple rules:

1. Photograph people walking, running, skating, skiing, biking (continuous movement) so that the people move *toward* or *away from* the camera instead of across the field of view.

2. Shoot *changing* action like that of golfers, ball players, and divers when the action reaches its *peak*.

Pick Your Angle

Ever notice how fast scenery seems to rush by as you look out the side window of a speeding car? Yet, when you look out of the back window, that car overtaking you hardly seems to move. It slowly grows larger and larger. Then suddenly it speeds by in a blur of color.

Your camera sees movement the same way. When you click your shutter, the car speeding past at right angles leaves a blur on the film. The closer the car to the camera, the greater the blur. But if the car were coming at you from a 45-degree angle, it would leave much less blur; and if you snapped it from behind, speeding away, you'd see hardly any blur at all. (You'd have to work fast, though, to fill your viewfinder, especially the way some people drive.)

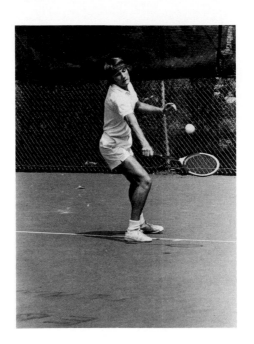

Probably you don't go around shooting speeding cars, although if you're like me, you sometimes feel an urge to shoot their drivers. But the above laws of motion apply equally to sledders, skaters, runners, hop-scotchers—anything you can think of.

Blurring

Don't misunderstand this discussion. Blurring doesn't always "spoil" a picture the way George thinks it does. Camera movement might do it, but that's not the same as the blur from a moving hand or leg of a kid playing with his dog. Some photographers even use slow shutter speeds on purpose to blur certain movements. The blur of a person's hand drawing circles in the air while he talks may tell a better story than all

the razor-sharp, stopped-dead hands in the world. The blurred face of a laughing child might give your picture a sense of realism and a "natural" look, because you never really see action as stopped movement anyway. So don't be afraid of blurred movement, even though you may want to minimize it by shooting at an angle.

But remember that subject blur will be most effective if you hold the camera *still*. A blurred hand or face or arm or leg must seem to move against a motionless background. Otherwise the whole snapshot may be unclear, and people will get dizzy looking at it.

Panning

Now that I've told you not to move the camera on action pictures, I'm going to reverse my field again and say there's *one* time when camera movement is O.K. That's when you use a technique called "panning." It means moving the camera steadily to *follow* the action the way a hunter tracks a flying duck with his gun. When you pan a photograph the right way, the background will blur, which is what you want it to do; but the moving subject will remain relatively sharp. You can even photograph movement at right angles to the camera this way, and give the effect of movement without serious blurring.

Let's say you want to take a picture like the one that shows Dotty riding a merry-go-round. First you line her up in the viewfinder and follow her around once or twice, moving the camera smoothly as she moves. You have to keep her in just about the same place in the viewfinder if you can. Then, just as she passes close by, you gently press the shutter *without* stopping or even slowing down the camera.

It's like firing a rifle at a moving target. If you make a direct hit your picture ought to look something like this one. Notice that Dotty seems fairly sharp *because* the camera moved at the same rate of speed as she did. But the background looks blurred just as in any moved-camera snapshot. Instead of spoiling the story, the blurring here helps to tell it. You'll find

Snapping the girl ice skater with a simple camera while she's flying by must result in a blurred shot like this one.

Having her move toward the camera allows a much sharper picture, though.

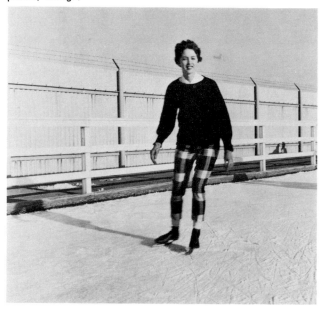

that this trick is worth adding to your bag to be used now and then when you want a little different kind of action picture. Try it. With a little practice you'll get pretty good.

Peak Action

Shooting action at its *peak* is another technique you can use to catch pictures on the move. The peak, of course, is that split second when an action comes to a climax. It's the slight pause of a leaping basketball player just before he releases his shot; it's the moment of suspense when a high diver has reached the top of his spring but hasn't started for the water; it's the instant of frozen motion at the end of a golfer's follow-

The blurring on Sylvia's hands as she throws leaves into the air helps tell this picture's story. You needn't worry about subject blur all the time if you hold your camera steady. Photo by Dotty Weisbord.

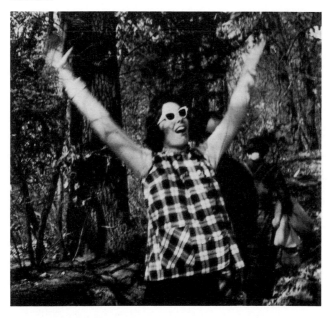

Deliberately following action with your camera gives a picture like this one. The background blurs, but Dotty is sharp.

through when he's just taken a wicked cut at the ball. In each case the action literally *stops* for a fraction of a second.

An alert snapshooter can convert this idea into good action pictures with practically any camera. I won't kid you, though. If you want to stop action dead at its peak, it would help to have an adjustable camera with shutter speeds up to about 1/300 sec. Nevertheless, speed alone won't get you a peak action shot. Even at 1/1000 sec., if you snap too soon or too late, you can miss the exciting moment. The secret of peak action pictures is *anticipation*. You can't afford to wait until you actually *see* the batter at the end of his swing. Reason? By the time your eyes send the message to your brain and the brain relays it to your shutter finger, the batter has started to drop his bat. The peak is past, and there's not much of a picture left.

THE EXACT INSTANT. But if you *anticipate* that follow-through, you can get an exciting shot at exactly the right instant. What you have to do is begin to press the shutter a

When action reaches its peak, everything stops for an instant. That's the moment to release your shutter.

split instant *before* the peak, say at the moment you see the batter start to swing. If the peak action and the opening of your shutter coincide you'll get a winner (but hold your camera still).

This technique, like all others, requires practice. But, like the others, it's worth it if you're interested in good action pictures. You can start with easy subjects like a kid on a swing or the shuffleboard player shown here. In that shot the boy has just sent his disc whizzing across the asphalt. For a split second he holds motionless—a perfect moment to click the shutter.

17. "But I Thought You Need Flash Bulbs Inside . . ."

George is used to seeing folks pop flash bulbs to take indoor pictures. So he was astonished to see his little nephew Herman clicking a camera all over the place at a big family dinner one night. Herman didn't use a single bulb.

"You don't have any film in there, do you?" George kidded.

"Sure do."

George scratched his head. "But I thought you need flash bulbs inside . . ."

Herman laughed. "Not when you're shooting available light you don't. I got an $f/2$ lens on here."

George doesn't know an $f/2$ lens from an ICBM. "Oh, I see," he said, "but I still don't see how you take 'em without flash bulbs."

Herman, precocious little brat that he is, really *was* taking pictures without flash. What George didn't understand is that Herman's camera has an *adjustable* lens opening, and that Herman can open up wide to make up for low room light.

Anyway, *existing-* or *available-light* photography means taking pictures by the light of anything from the silvery moon to floor lamps, ceiling bulbs, street lights or windows—whatever happens to be available outside of flash bulbs or floodlamps. Unfortunately, the simple box camera won't admit enough light from a table lamp to make a good picture (unless you make a time exposure, which we'll get to in a minute). This doesn't mean you can't take indoor shots with a box camera and no flash gun. There are ways, though George never thought of them.

Know Your Speeds

To avoid confusion later, something should be made clear right here. In photography we talk about three different "speeds." George has never straightened them out, which is partly why he's such a confused picture-taker. He needn't be. The three speeds really are pretty easily understood. Here they are:

1. *Shutter* speed— the one you hear mentioned most often. It's the length of time your shutter stays open after you click the button. A camera's shutter speed is usually set somewhere between 1/30 and 1/50 sec. An adjustable camera generally has shutter speeds ranging from 1/500 or 1/300 sec. or higher, down to a full second.

2. *Film* speed—this speed refers only to a film's *sensitivity to light*. It's the speed discussed in Chapter 6.

3. *Lens* speed—here's the one that confuses most people. Unlike the other two, it refers to the *amount of light* a lens will admit to the camera when wide open. A "fast" lens admits a lot of light, a "slow" lens relatively little. For convenience, lens speed is expressed by "*f*/number." The *lower* the *f*/number, the *faster* the lens, and the *more* light it will admit.

If you're a fixed camera user, you might as well skip ahead to the section titled "Available Light with a Simple Camera." You don't need to know what follows in order to take good in-

"Available light" shots are easy if your camera has an f/3.5 lens or faster and adjustable shutter speeds. Notice in the doctor and baby picture that, although light is coming in the window, the main source is the fluorescent fixture in the room.

door pix. If you use an *adjustable* camera, however, stick around for a few more paragraphs, while I explain something you may not have known before.

F/numbers. In an *f*/number, the "*f*" stands for focal length. This is the distance (usually given in millimeters or "mm") from the middle of your camera's lens to the film—when the camera is focused at infinity (any distance beyond 100 ft). The normal focal length of most 35mm camera lenses runs between about 45 and 50mm, or about 2 inches. Most twin-lens reflex cameras have focal lengths in the neighborhood of 85mm.*

An *f*/number, then, like "*f*/2," is really a *fraction* which can be read "*f* divided by 2." Knowing this, you can figure out the diameter of any lens opening (in millimeters or inches) by dividing the focal length by whatever *f*/number the lens is set for. Take Herman's 50mm *f*/2 lens. When it's wide open, the diameter of the opening is 50mm divided by 2, or 25 millimeters, which is about an inch. At *f*/8 the lens opening would only be about 6 millimeters, or ¼ inch, and naturally it would admit lots less light—only 1/16th as much, in fact.

So that's where the *f*/number comes from, and the most important things to remember about it are:

(a) the higher an *f*/number, the slower the lens at that opening;

(2) each time you move a lens to the *next* higher *f*/number, you cut the light coming through it in *half*.

Back to Herman

The most interesting thing about Herman's *f*/2 lens, then, is the fact that when it's wide open it will admit double the amount of light of an *f*/2.8 lens and better than four times as much as an *f*/4.5 lens. To take good pictures you don't need to know how *f*/numbers are figured, but realize this: the average box camera's lens is permanently set at about *f*/11. The way the numbers run, if you open a lens from *f*/11 to *f*/2 you let 32 times more light into the camera. That's why Herman

* Don't confuse 35mm cameras (which use a film whose *size* is 35mm) and 35mm *lenses*. When you're talking about a camera, the 35mm refers to film size. When talking about lenses, it refers to focal length.

doesn't need flash bulbs inside. He can always set his lens wide enough for whatever light happens to exist in the room. And, if necessary, he can also reduce his shutter speed and admit light to his camera for longer periods of time too. George can't.

AVAILABLE LIGHT. If you own an adjustable camera like Herman's, you're in the existing-light business whether you know it or not. In fact, you don't even need an $f/2$ lens at all. An $f/3.5$ will do fine. You'll need a fast film like Tri-X or High Speed Ektachrome. And you'd do well to own an exposure meter (or "light meter,"), because you really can't tell how to set shutter speeds and apertures in low light without one.

However, if you have no light meter, you *can* make some pretty good guesses. For a starter, you might experiment with 1/10 sec. at $f/3.5$ or 1/25 at $f/2.8$ in average bright lamp light, the kind you find in most living rooms. Sit somebody in a chair so that the light from a 100-watt bulb falls directly on his face, and you should be able to get his picture at the above speeds. In rooms lighted by banks of fluorescent lights you'll probably do all right at 1/25 and $f/4$ or even 1/50 at $f/4$; but you'll have to find this out for yourself. Remember, of course, that it probably takes a steadier hand than yours to hold a camera still for 1/10 sec. or longer. So you'd best set the camera on a table or a chairback at lower speeds, or use a tripod if you have one.

If, after a few rolls of film, the available light bug bites you, you probably have an incurable disease. Fortunately it isn't fatal. The wisest thing to do is buy a good exposure meter and read a book like H. M. Kinzer's *Available Light Photography,* published by Amphoto, Garden City, N.Y.

Available Light with a Simple Camera

You can't adjust a box camera; so you can't take low-light pictures with it. Still, if you use a little ingenuity, there's plenty of light "available" to you in the house. You need enough light to make an image on whatever film you're using,

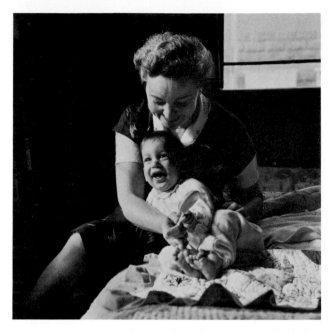

Sunlight streaming through a window allows you to take indoor shots like this one, even with a simple camera.

and "enough" means something close to daylight out-of-doors. Here are two easy ways to make indoor box camera snaps, using films of different sensitivity:

1. Use daylight, either direct sun or bright window light.

2. Buy a No. 2 photoflood bulb and screw it into an open socket, and use "Fast" film.

Let's see how you do each of these.

DAYLIGHT. This one seems so obvious you must laugh at it. But don't. George never thought of taking *indoor* pix by sunlight, and I know lots of other people who never did either. But sunshine will expose your film just as surely in the dining room as it will in the yard. Watch for sun coming in through doors and windows. You might find a beautiful sunny corner in the living room in the morning. By afternoon, sun may be coming into the kitchen or a bedroom. Few houses *never* get any sun during the day. When the sun finds its way into your

house, you can make excellent snapshots without setting foot outside. But make sure that whatever you're snapping is fully lighted by the sun. Dark shadows become black patches on a finished print.

Notice Grandmom and child playing on the bed by morning sunlight. George would never dream of making this kind of informal snapshot; but you can do it easily, and with an Instamatic-type camera.

You can also make Instamatic pix by window light without *direct* sun. But you'll need a fast film like Tri-X or High Speed Ektachrome. When outdoor light seems pretty bright, move Mom or one of the kids over by the window. See to it that the bright, even light falls on the face. The film's latitude ought to take care of your exposure, and, though your finished print may be a little dark, it will often come out quite nicely.

With **fast** film you can make pictures by bright window-light, even if the direct sun isn't shining in.

Simple Flood Lamp. Most snapshooters, George included, aren't inclined to follow the lighting tables printed on the little slip of paper that comes with each roll of film. This is a pity, because by following the tables you can make beautiful indoor pictures. But you'd need at least two photoflood lamps with reflectors; few people will bother.

I've tested another simple procedure for indoor box-camera pictures which gives good results with little fuss. If you have open ceiling sockets in your house, you can save flash-bulb money with this system:

1. Buy a No. 2 photoflood bulb in a hardware or camera store. The bulb costs but it will burn for 6 hours and give you enough light for hundreds of pictures—more, in fact, than you'll probably ever take. Flashbulbs, or flashcubes, on the other hand, cost 12 to 16 cents per flash.

Examples of "cube" photography. This picture of Becky, taken in bright sun, shows harsh shadows on her face.

In this shot, a "cube" fills in the shadows, revealing detail and highlights in the eyes. David Willis photos.

2. Screw the photoflood bulb into a ceiling socket or other open fixture. (Remove lamp shades or reflectors.) Keep your own and the kids' hands away from the burning bulb, because it really gets hot.

3. Load your camera with Tri-X roll film (very fast).

4. Set your subject so that the light falls full on him from about 6 or 8 ft away. The closer the subject to the light the better your exposure.

5. Shield your camera lens from the bulb's direct rays (just as you would from the sun). And take pictures.

Tri-X Pan is so sensitive to light that this set-up will give you adequate light even with drugstore processing. The effect you get looks about halfway between a flash bulb held high and to one side and normal room light. But you needn't worry about how far your *camera* is from your subject. Just make sure the *light* is fairly close and direct. You get a little more mobility this way than with flash-on-the-camera, and you also can get candid pictures, especially of kids who may be frightened by popping flash bulbs.

Pictures With a "Cube"

In the past decade, there has been a revolution in simple flash photography. I refer to the Flashcube, or Magicube, or Supercube, a simple device permitting four consecutive flash shots with simple cameras, indoors or out. Cubes cost less than flash bulbs. They require little fuss—less, indeed, than the use of a floodlamp. The various cubes give excellent results. Indeed, outdoors, they compensate for low light, harsh shadows, or subjects in the shade—making it possible for snapshooters to take a whole range of pictures with adequate exposure and little bother.

A flash picture made with the bulb too close to the subject shows overexposure and loss of detail in shirt and face. A single fold of handkerchief over the flashbulb reduced the light enough to make the closeup at right. Moving back to correct guide number distance would give the same result.

18. "What Happened to the Faces?"

George and flash bulbs are allergic to one another. Oh, sure, he knows how to hook up the flash attachment and fire it. But he can't understand why his finished pix often look either too dark or too light.

"What happened to the faces, dear?" asks Mrs. George, studying the New Year's Eve shots. "They all came out but the faces seem so . . . so white. You can't even see Joanna's features at all—and she looked so cute that night!"

George mumbles something under his breath. "Must be those flash bulbs," he says out loud. "Maybe I got the wrong kind."

Mrs. G. pulls another print out of the pile. "Look at this one," she says. "Frank looks O.K. there, but how about Frances? She seems all in the dark. George, you ought to get a camera like Bill Preston's. His flash pictures always look beautiful."

Because I invented Bill Preston as well as George, I know the difference between their pictures has nothing to do with cameras. It's just that Bill knows how to use flash bulbs; George never learned. Actually, you don't have to be a mental giant to make good flash pictures. But you do have to follow certain rules, some of them requiring nothing more than common sense.

Whether or not you *will* make technically good flash pictures depends mainly on *how far* your subjects are from the flash. For adjustable cameras you set shutter speeds and lens openings according to subject distance. For box cameras, you decide in advance which *distance* gives you good light for the film and bulbs you use—and take all of your flash pictures from that distance. Let's talk first about box cameras.

Flash with a Simple Camera

The farther light travels from a flash bulb, the weaker the light becomes. Although at certain distances a flash bulb's light is as good as sunlight, there's a world of difference between the two. The sun lights a scene evenly. The flash bulb lights a scene brightly toward the center, less brightly toward the back and sides. That's why backgrounds look so dark in some flash pictures. You can photograph dancing couples with a flash in a crowded ballroom. But the couples dancing 15 or 20 ft away are sure to be dancing in the dark in your picture. On the other hand, a couple dancing 5 or 6 ft from the flash receive a great deal of bright light. The girl's white gown may look solid white, the ruffles and buttons blasted out by a flash of light. Within the *correct* distance range, however, (usually about 8 to 12 ft), exactly the right amount of light falls on your subjects to light them evenly and bring out details in faces and clothing.

How Far to Stand. What this "right" distance is for your own camera depends on two things: (1) how sensitive to light your film is and (2) how powerful your flash bulbs are.

Evidently a film like Tri-X (fast) may be exposed correctly from a greater distance than Plus-X Pan (medium speed), using the same bulbs. Most cameras take either No. 5 or Press 25 flash bulbs, or the new miniature flashcubes, which give four flashes without changing bulbs. Tests with simple cameras have shown that bulbs or cubes work best between 8 and 12 ft with medium speed films like Verichrome Pan. With Panatomic-X you can move in to between 6 to 10 ft; with Tri-X Pan you can get good negatives between 10 and 15 ft with No. 5 bulbs.

If, like George, you've taken some washed-out-face pictures in the past, probably your subjects were too close to the flash for whatever film you were using. A subject lighted by a No. 5 bulb and standing, say, 5 feet from a camera loaded with

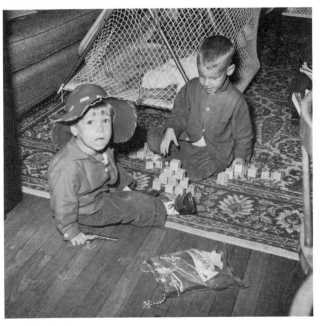

High-angle flash shots tend to distribute light equally over a large picture area. Light is more evenly balanced from front to back.

a medium-speed film would give you an overexposed picture, causing what's called a "blocked-up" area on the negative. Take a look at a washed-out-face negative some time. You can clearly see the blocking. The faces seem dense and black. This density allows very little light to pass through the negative. Hence lack of detail. By planning all of your flash pictures for the *average* distances listed above, you need never wonder where the faces went.

Flash Tips

Here are some fairly flexible rules to help you improve your flash pictures with any camera:

1. Always try to keep the people in your pictures about the *same* distance from the flash bulb. That way the light will strike each person evenly. Try shooting a group sitting on a sofa from nearly in front of the sofa rather than from one end. Each person will get nearly the same amount of light. It's more difficult to make a flash picture of people sitting around a dinner table. Aunt Mary, 'way down at the end of the table far from the camera, can't possibly receive as much light as Uncle Charles, sitting practically under the photographer's nose.

You can solve this lighting problem two ways. Move everyone around so that all are sitting about in the same plane (perhaps along one side of the table). Or, climb up on a chair and make a high-angle picture. High-angle shooting with flash bulbs tends to equalize light over a deep area. By getting up above Uncle Charles, you move the light farther from him without moving it much farther from Aunt Mary. If Aunt Mary is then 7 or 8 ft from the camera and Uncle Charles about 12 ft, your picture will be fairly well lighted over all.

2. Since it's impossible to have *everybody* exactly the same distance from the flash bulb, arrange people according to their clothing. White shirts and blouses reflect a lot of light. Navy blue coats and sweaters reflect little light. So put the light-colored shirts farthest from the camera, the dark sweaters

Moving the white shirt farthest from the flash bulb will help equalize light in a flash picture.

closest. This will help balance the light over the whole picture.

3. To prevent washed-out faces in close-up flash pictures, place a single fold of handkerchief over your flash gun in front of the bulb. This will cut the light down. If Aunt Susy is sitting about 5 ft from the flash, you can get good detail in her face without having to back up. But don't expect to get the same detail in the face of Uncle Fred 10 ft away. His face is bound to be darker. Move him next to Aunt Susy if you want both evenly lighted.

4. Make sure your flash gun's batteries are in good shape. Weak batteries reduce the strength of a flash. Thus, even though the gun goes off, it doesn't put out its maximum brightness. If you get a run of dark or unprintable flash pictures, you might check for weak batteries.

5. Just because you're using flash bulbs doesn't mean your subjects have to strike stiff poses. Flash pictures should be interesting pictures too. They ought to have simple backgrounds, strong centers of interest, and good action. Don't let your subjects pose. Make them do something—eat, talk, joke, or at least relax—before you pop your flash bulb.

Guide Numbers

With an adjustable camera you can regulate distances by "guide numbers." They make it possible to shoot at small lens openings for subjects near the flash, and wide openings for subjects far away. You can also cut or raise the amount of light reaching your film by changing shutter speeds.

The guide number is assigned to your film according to its sensitivity and the shutter speed you're using. The slip of paper packed with your film will give you a list of guide numbers, but you'll also find them on the back of every flash bulb package. Here's a typical chart for No. 5 bulbs with a 4-6″ polished reflector:

With "M" synchronization . . . use any shutter speed.
"X" or "F" synchronization . . . use 1/30th or slower.

Tungsten Film Speed	16	20	25	32 40 50	64 80 100	125 160 200	250 320 400	500 640 800	1000 1250 1600
1/30 or slower	110	120	130	170	240	340	480	700	950
1/50 & 1/60	95	100	120	150	200	300	420	600	850
1/100 & 1/125	80	90	100	130	180	260	360	500	750
1/200 & 1/250	70	80	90	110	160	220	320	440	600
1/400 & 1/500	55	60	70	90	120	180	240	360	480

° For Diffuse or Folding Fan Reflector multiply Guide Number by .7.

Let's assume you're using Verichrome Pan film with a rating of ASA 125 and No. 5 flash bulbs. Match the 1/200 line with the 125-160-200 tungsten film-speed column. You'll find a guide number there of 220. To get your lens opening, simply divide the distance in feet from flash bulb to subject into the guide number. If your wife sits 10 ft from the bulb and you

divide 10 into 220 you get 22, or, in terms of lens openings, $f/22$.

Now, if the $f/$number you get this way comes out much *higher* than any you have on your camera, you must *increase* your shutter speed to cut down on the light and figure the guide number again. In the example given, notice that if you decide on a shutter speed of 1/400 sec., you'll get a guide number of 180 instead of 220. Dividing 10 ft into 180 gives you $f/18$, or, rather $f/16$, which is the nearest available lens opening.

The Lazy Man's Way

I have a friend who always gets good flash pictures. "I'm lazy," he says. "I never bother with guide numbers, or distances, or all that jazz. I just always use medium-speed films, No. 5 bulbs, set my camera for 1/250 at $f/16$ and take all of my pictures 10 ft from whatever I'm shooting. I've never gotten a bad flash yet."

And you know something? He hasn't!

Nevertheless, you must use your head. If 1/250 at $f/16$ gives you overexposed negatives, stop down to $f/22$ next time at the same distance, or else move back.

19. "It Ought to Be Enlarged!"

Last winter George went wild over a picture he took of the two kids. It shows them building a snowman in the backyard. "You'd hardly even know it was posed," says George, proudly. "It ought to be enlarged." He rushes off to the drugstore with his prizewinner.

"Can this negative be enlarged?" he asks the clerk.

"Sure. What size you want?" The clerk points to a cardboard display showing half-dozen perfect enlargements, pictures of girls in bathing suits.

"You can have 4 by 5, 5 by 7, or 8 by 10," the clerk says. "Cost you 35¢, 50¢, or 85¢."

"Well," George says, "that's great. Gimme . . . let's see . . . two 5 by 7's. Ought to look pretty nice, huh?"

The clerk nods and drops George's negative into a yellow envelope. "Pick 'em up next Thursday at noon," he says.

On Thursday George rushes home with his new enlargements, eager to share them with Mrs. G.

"Yes, dear, they're very nice," she says.

George's mouth quivers. "That all you have to say?"

She studies the pictures again. "Well, couldn't you do something about all those trees over on the side? How come it's kind of blurry? And where did that beer can on the ground come from? Imagine! In the same picture with the children! I didn't even see it in the little print. You and your enlargements."

George clutches his pictures like a losing TV contestant with a carton of cigarettes. "Well," he says, "they're going in the album anyway. I like them and I'll bet Grandma will, too, beer can or no beer can."

Mrs. George, forever a Mona Lisa, smiles. "I'm sure she will, dear."

George isn't the first man to order enlargements hoping for better-looking pictures than he gets. Nor will he be the last. The idea of pasting a giant print into the family album next to all the little ones is almost as appealing as giving a framed enlargement to a relative for Christmas, especially when you

took the picture yourself. But don't rush headlong to the drug-store the way George did until you understand how to get good enlargements.

What You Need

There's no point trying to enlarge a negative which is blurred, out-of-focus, badly scratched, or dense and grainy. Don't kid yourself. If your small print doesn't measure up in all these departments, your enlargement won't. When you blow up a photograph, the defects get bigger along with the faces. To get a good enlargement you need:

1. A *sharp negative.* This is one department where the more expensive adjustable camera gives you definite advantages. The better the camera's lens, the sharper your negative. And the sharper the negative, the bigger the enlargement you can make. This doesn't mean you can't enlarge shots taken by an Instamatic. But you'd be wise to stick to small enlargements, certainly no bigger than 5″ x 7″. Remember, too, that camera movement can make *any* picture unsharp.

2. A *well-exposed negative.* If your negative is dense and grainy or nearly transparent, it won't make a good enlargement. Nobody can take away grain or add detail you didn't have to begin with.

3. A *carefully-focused picture.* No matter how good your lens is, unless you focus your camera carefully your picture may be unsharp. Perhaps this won't be noticeable in a small double-size print. But it'll show up in an enlargement. So will camera movement. With a fixed-focus camera, don't bother trying to enlarge pictures taken at closer than 5 or 6 ft (unless you use a closeup attachment).

4. A *properly-developed negative.* If you shoot roll film according to the instructions previously given, the drugstore will give you proper development. But this doesn't hold for 35mm black-and-white film. Small negatives require *fine-grain* developing, often a special service which costs more. Standard processing is O.K. for 35mm film if you don't expect

to make enlargements. But if you do, ask for fine-grain. It's worth the difference.

5. *A clear idea of what part of your picture you want enlarged.* Most snapshooters don't know this, but you *don't* have to take the *full* negative when you buy an enlargement. You can get *any* portion blown up to any size for the same price. Deciding which part of a picture you want enlarged is called "cropping." Few snapshooters have ever heard about this, so I'll go into detail hoping it will help you buy better enlargements if and when you decide to.

How to Crop a Picture

Remember how regular over-size prints are made? A man runs your negative into a machine which projects them up to about 3″ x 3″. They're really small enlargements, but they include the *full area* of your negatives. Bigger enlargements are made the same way, except that each negative gets individual attention. So, while he's at it, the man can blow up *only* the important sections of a negative and leave everything else out. You're paying him for this service anyway, so you might as well have it.

To have your enlargement cropped the way you want it, you simply have to tell your finisher what stays in and what goes out. You can get rid of sky, lawns, trees, ash cans and beer cans by indicating that the only thing you want enlarged is the area where the kids are. How do you do this? Simple. Take a grease pencil and a ruler and draw lines around what you want enlarged. Or mask off the area with masking tape. Or mark the edges of the print with pen and ink at the points where the negative should be cropped. Give the finisher the small print along with your negative and he'll do the rest. None of these methods, by the way, will spoil your small print. Grease pencil rubs off with a finger, masking tape can be carefully pulled from a glossy surface with no strain, the ink marks (on the edges only) will hardly be noticeable.

Every time you order an enlargement, then, you have a chance to improve your picture by careful cropping. Don't pass it up. If you doubt whether a certain negative will enlarge O.K., ask your finisher's advice. Even a drug clerk who doesn't have the answer will know who does. He can find out in advance whether it pays you to buy a certain enlargement and save you pain and money later on.

Custom Finishing

Before I finish this chapter I ought to mention one service most snapshooters don't know about. That's custom photo finishing. This is a personal, high-quality service offered by certain film laboratories, and some photo stores, mostly in larger cities.

The custom finishers are experts at making enlargements. They produce outstanding quality prints from good negatives —far better prints, in fact, than either you or I might make in our own darkrooms without years of experience. For the kind of enlargements you might want to frame over the mantelpiece, a custom finisher is the man to see. His prices run higher than the drugstore's, but he gives your films and prints individual attention.

And he offers a variety of services. He will fine-grain develop your roll film for exactly the right length of time to give you perfect negatives. He'll make enlargements up to and including prints the size of your living-room wall (if your negatives are good enough). What's more, he offers color developing, printing and enlarging, photo mounting, and many other little extras which he can tell you about better than I can.

Most custom finishers deal by mail, and you can find their ads in the photography magazines and Sunday papers. Their services are especially worth while for the 35mm black-and-white fan who doesn't want to do his own processing.

CONTACT PRINTS. While I'm at it, I might as well express an

Here's George's original oversize print. If he orders an enlargement, the **entire** picture will be enlarged—unless he crops it.

A cropped enlargement of George's snapshot shows the face alone. Unimportant background was removed in enlarging. You need a sharp negative to get this result, though.

opinion of mine. If you're shooting 35mm black-and-white film, 36 pictures at a time, then giving them to the drugstore to process, you're probably throwing money away. You're paying 8 or 9 cents times 36 for your prints, and probably half of them aren't worth a cent to you or anybody else. A custom finisher can give you "contact prints" of your entire roll of film on a single sheet of 8 x 10 inch paper. Contact prints are exactly negative size. They enable you to see which pictures are good, which fair, and which not worth bothering with. Then you can turn around and order enlargements of the good ones only. The money you often spend on poor prints can be put into *more* film, and, if you practice, better pictures. It will cost you about $3.00 to have a roll of 35mm film fine-grain developed and contact printed. This is a service worth looking into, although my friend George wouldn't bother.

20. Pictures Are Where You Take Them

George, as you learned in the first few pages, likes to take snapshots of people he knows. He isn't a picture-nutty shutterbug who can't keep his hands off a camera. He likes pictures of his family, pretty scenery, historic buildings, and that's about it. He isn't much interested in self-expression.

Most people get a kick out of looking at old pictures. "Boy, were the hats funny-looking back then." "Wow, have the cars changed!" "Hey, remember when we went to Grand Canyon?" Each snapshot, a chapter in your personal memory book, adds some interest and joy to your life. Now that you've read this book I hope your own snapshots begin to show enough life and color to give the family some extra kicks for years to come. If they do, you're ahead of George forever.

But there's one thing more—a suggestion you can ignore if you want to. I suppose that each of us, George included, has a little creative spark, the desire to make or draw or model or sing or write something that wasn't there before. I can't think of a better way to ignite and fan that spark than with a camera.

It's great to have snapshots of your family and friends, your home, your vacation spots. But your camera will do more than take snapshots. You can use it as a means of seeing with your own fresh, creative, imaginative eye. Henri Cartier-Bresson, the world-famous photo-journalist, calls the camera an "extension" of his eye—a tool to help him see the world, make some sense out of it, and show it to others his own way.

How about *your* way of seeing? What excites you? Is it a sunset, a crowd of Saturday shoppers on Main Street, the kids digging in a sandbox, a baseball game, picnics, trees, colonial houses, or what? Can you translate your excitement into a photograph? Can you pick the right angle, the proper time of day, the exact kind of lighting, the most effective grouping of people, the best gestures and expressions to tell a story *your* way? It's being done every day by thousands of photographers

A contact sheet like this one shows you which pictures are worth
enlarging before you pay for an oversize print of each one.

all over the world, which satisfies all of them and enriches the world's storehouse of good pictures.

Did you happen to see "The Family of Man," that wonderful exhibit of pictures from every corner of the earth, compiled by Edward Steichen? If not, you can buy the whole collection for a dollar or so in a paperbound book on many newsstands. It's worth owning. In it you see the whole saga of courtship, marriage, birth, childhood, adulthood, old age, and death, among all the world's people's, a story told completely with photographs. Some are the best you'll ever see. Each photographer with a picture in that exhibit started just the way you did: he didn't know the first thing about picture-taking. But he learned.

The funny thing is that a good photographer doesn't need an African safari or a seat in the press box to take good pictures. He sees excitement in his own backyard, on his own block, in his own living room.

One of the best photographers I know is a salesman who carries his cameras on trains, planes, and buses. Two of his prize-winning pictures have been shown all over the world. You know where he took them? Not in Singapore or South Africa, but out of the window of a hotel where he happened to be staying—in Boston. Beauty, drama, excitement are around you all day long, if you know how to look and where. After all, Wayne Miller, the photographer who did that exciting book "The World Is Young," isn't the only man in the world with four growing children and a miniature camera. He took 30,000 pictures for his book without ever leaving home.

Pictures, when you get right down to it, are where you take them: everywhere, if you look; nowhere, if you don't. Now that you've read this book and taken some pictures I hope you'll begin to really look. I hope you take lots of good pictures wherever you are, whatever your subjects.

And if, while you're out shooting, you run into my friend George, ignore him. It's his camera and his film, and, as the saying goes, it's a free country.

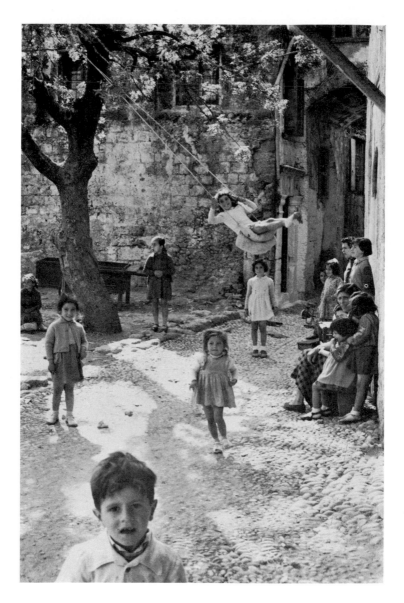

Photo by Howard Rosenberg.

Photo by David Willis